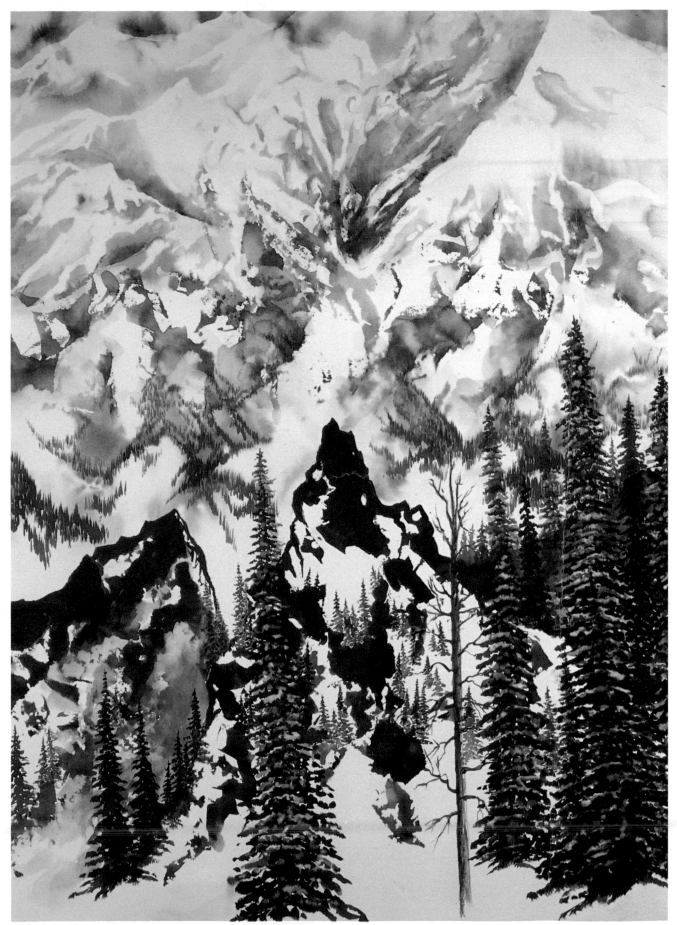

PINNACLES, dye color and watercolor ink on watercolor paper, 14″ × 20″ (35.5 × 50.8 cm).

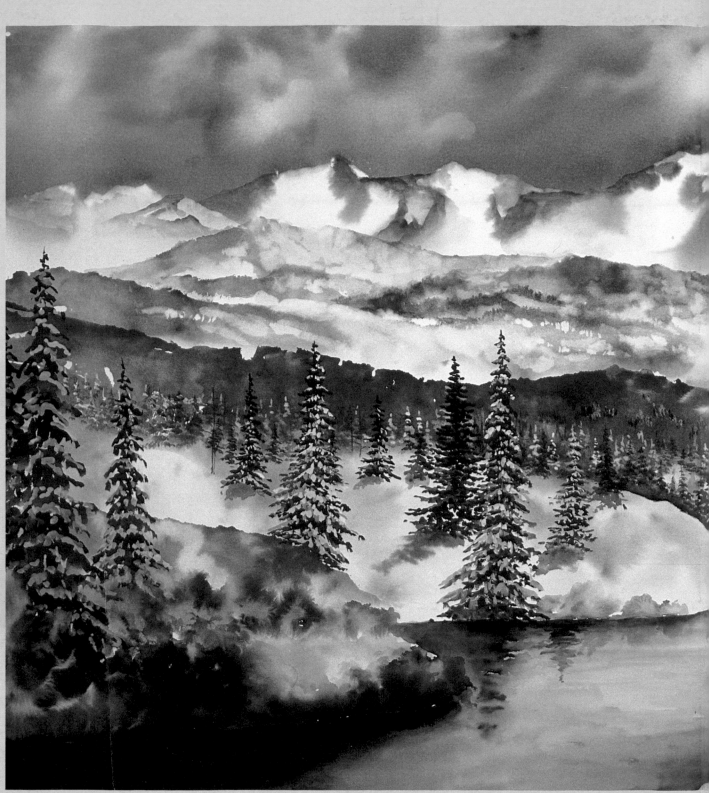

SNOWPACK, dye color and watercolor ink on watercolor paper, 12"×16" (30.4×40.6 cm).

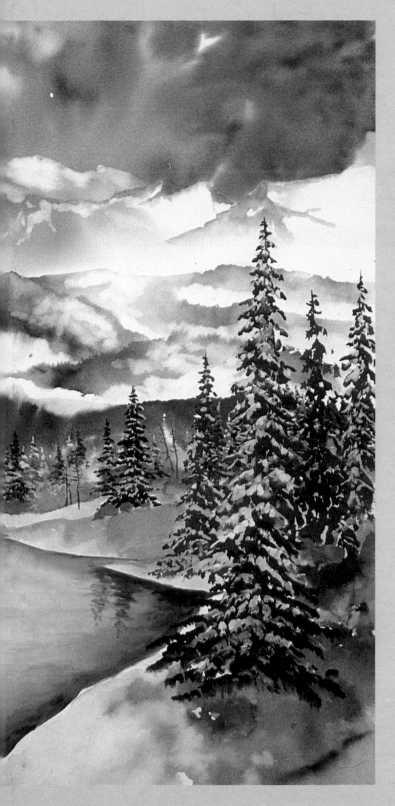

COLOR TRANSFER
Bill Senter

WATSON-GUPTILL PUBLICATIONS/NEW YORK

To my dear wife, Loraine, who has always been my greatest source
of encouragement, and to my dearest daughters, Carla, Pam,
and Keri, who have been the joy of my life.

I thank Mrs. Ruth Erwin of Colorado Springs, Colorado, for
teaching me the basic skills of painting and for helping to
instill in me a love for nature; and to Irv Graves, a good
friend from Denver, Colorado, who for the past thirty years
has explored the mountains with me and who reverences
them with the same degree of veneration as I.

Edited by Grace McVeigh
Graphic Production by Ellen Greene

First published in 1990 by Watson-Guptill Publications,
a division of BPI Communications, Inc.,
1515 Broadway, New York, N.Y. 10036

Library of Congress Cataloging in Publication Data
Senter, Bill.
 Color transfer: achieving impressionistic effects with watercolor
markers and inks / Bill Senter.
 p. cm.
 Includes index.
 1. Watercolor painting—technique. 2. Dyes and dyeing. 3. Ink.
I. Title.
ND2422.S46 1990 90-37909
751.4′2—dc20 CIP
ISBN 0-8230-5645-7

Distributed in the United Kingdom by Phaidon Press Ltd.,
Musterlin House, Jordan Hill Road, Oxford OX 2 8DP
Distributed in Europe, the Far East, Southeast and Central Asia,
and South America by RotoVision S.A., 9 Route Suisse, 1295-Mies,
Switzerland.

Manufactured in Singapore
1 2 3 4 5 6 7 8 9 10 / 94 93 92 91 90

CONTENTS

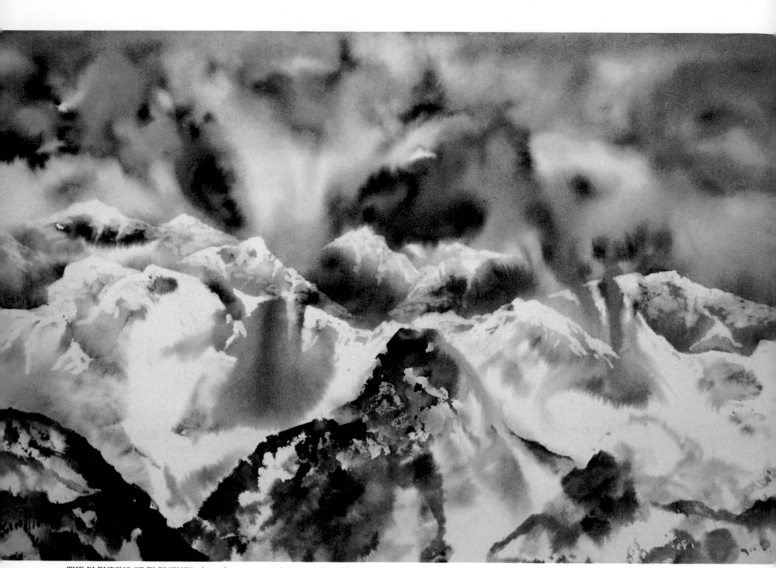

THE BLENDING OF ELEMENTS, dye color on watercolor paper, 16″ × 20″ (40.6 × 50.8 cm).

When the sky becomes turbulent over snow-covered mountains and the snow is whipped into a frenzy, the blending of elements is awesome to behold. When snow and wind are engaged in such convulsions, it is difficult to determine where mountain peaks end and clouds begin. Some portions of the mountain may appear to be sky, and some portions of the sky take on the shape of mountains owing to their soaring cumulus piles. I could not demonstrate a better example of the softness, transparency, and beautiful delicate color produced by bleeding dye through rice paper than you see in this painting. This luminosity cannot be produced with any other medium. The painting is atmospheric and ethereal yet sensuous.

INTRODUCTION

For the past forty years, I have backpacked through the mountains of western Colorado and northern Wyoming. I have traversed boulder slides and canyons, crossed fallen timber fields and high meadows, walked through dense pine forests, and camped beside streams and glacier lakes. These experiences have left a profound impression on me and have been a strong stimulus for developing a style of painting that best depicts such places.

Anyone who has spent time in the high mountain ranges knows that the environment becomes an ever-changing image owing to the constant variety of light and shadow produced by turbulent skies, which affect the surrounding formations of land, rock, vegetation, and water. Glistening limestone and granite surfaces of canyon walls, crystal clarity of glacial waters, translucent markings on trout, shimmering aspen groves, and churning cloud and fog formations reflect the transient nature of these landscape elements.

For me, this kaleidoscope of hues and intensities of light created by the swinging moods of storm and sunlight could be properly expressed only by a transparency, fluidity, and iridescence of color that surpasses that of conventional watercolor. Not only was it imperative that I find a method that best expressed the transparency of light and changing color but one that could be spontaneously applied to blend the various landscape elements together into a harmonious whole.

Because I respond passionately to the mountain landscape, I am eager to express these feelings eloquently. This means I had to select the most expressive medium possible for making my personal statement. I conducted much experimentation using transparent water-soluble dyes, inks, and bleaching agents to produce the effects that would best exemplify my emotional responses to the mountain landscape. I found that if I applied a number of hues from dye markers to the surface of various grades of Japanese rice paper and bled them through the paper to the surface of a watercolor paper by the application of moisture, I would receive a number of the qualities I had sought, as well as a more personal expression. Dye markers are felt-tipped water-based dye colors.

I came by my method of painting partly acciden-

tally. Some years ago after jotting down a note with a black watercolor marker on a table napkin, I mistakenly spilled some water on the napkin and was surprised at the many colors that spread across the porous paper, with a filmy quality unknown to tube watercolors.

There are many variables in this method of painting, such as the surface quality, weight, and absorption rate of the watercolor paper receiving the explosion of color from the moistened rice paper, the decisions made in bleeding the dyes and inks onto dry, wet, or moist paper, and the choices you make about the color effects you want to achieve.

The techniques I have invented are not intended to be something in and of themselves but are only a means to an end. They provide a way in which to individualize an artistic statement. Technique should not be a gimmick but should be subservient to the subject at hand. I use the watercolor brush sparingly in my approach. I have learned to work with a number of porous papers, such as paper towels, dinner napkins, and even facial tissues, for receiving color from dye markers. In some instances, these papers are the final resting place for the dye colors, since I consider some of the washes as finished paintings, but in most cases the papers act as merely temporary depositories of color, which I pass on to the surface of watercolor paper by adding moisture.

Because of the extremely fluid nature of dye and ink, control is the most difficult problem facing the artist. The speed of the expanding color and the direction of its flow are two areas that demand artful management. Part of the answer lies in controlling the drying time and correctly placing the moisture on the color. Having worked out most of the kinks in this approach to painting, I will describe the process in some detail so that the reader will be able to bypass problem areas and arrive at some portion of immediate success.

The painter investigating my color transfer techniques must be persistent and patient if he or she expects to reach a high level of proficiency. I believe, however, that this will be a small price to pay if the result of such persistence is a more skilled artist who has expanded his horizons in personal expression, and it is to this end that I have prepared this book.

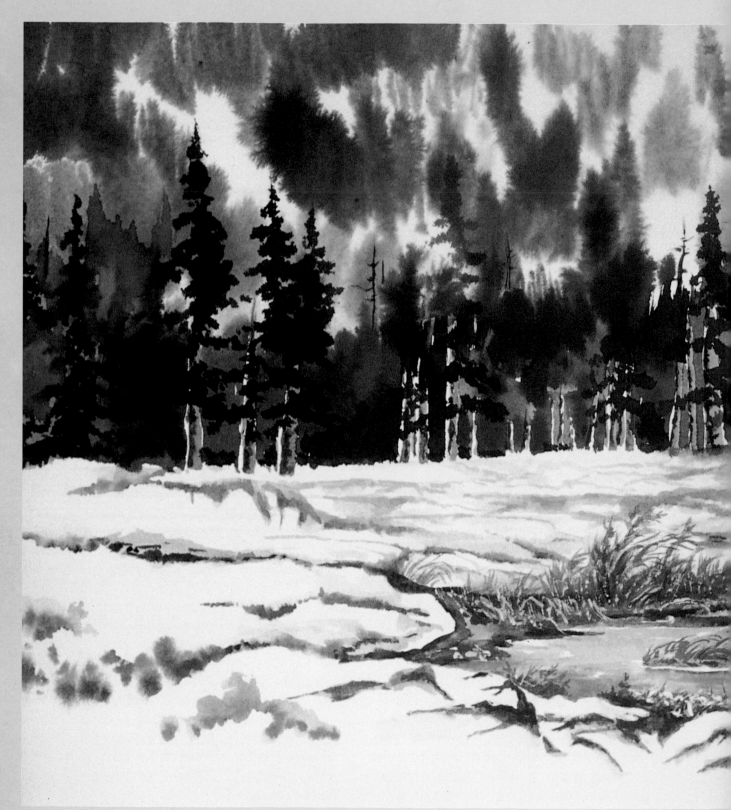

WINTER MEADOW, watercolor ink on watercolor paper, 10"×14" (25.4×35.5 cm).

MATERIALS AND COLOR EXERCISES

MATERIALS

DYE MARKERS

Dye markers are felt-tipped water-based dye colors. These are watercolor, nonpermanent markers, as opposed to permanent markers. Permanent markers are alcohol-based markers, which will not react to water. The size of the marking tip varies from a small writing point to broad one-half-inch surfaces. These dye markers can be purchased in various-size sets or individually at most art supply stores. A small set of primary and secondary colors is all that is needed to get started, though I recommend that a serious artist collect as many varying hues as possible to better facilitate his expressions. A typical color palette will include two or three black dye markers that vary in color composition, several shades of the primary and secondary colors, plus several shades of brown.

There is a great variety of water-based dye marker brands, sizes, and qualities. They can be found in school supply stores, dime stores, and arts and crafts stores across the country. The quality of the color has little relationship to the cost of the marker. They are usually inexpensive in comparison to some of the quality brands of watercolor paints, though a marker does not last as long as a tube of paint. Broad-tipped markers are the most functional for the purpose of painting, although occasionally a marker with a small pointed tip can be used for some areas of detail. Some of the brands I use are Watercolor Concept, produced by E. F. Eberhard Faber, Inc.; Magic Marker; Liquid Crayons; and Mr. Sketch, made by the Sanford Co.

Dye markers are perishable if they are not properly protected. The caps must always be replaced immediately following use, since the marker's felt tip and dye well will dry up if left exposed to air for any length of time. Also, marker tips should not be immersed in water because this dilutes and restricts the flow of color from the marker.

I organize the large number of dye markers I have acquired in a way that allows me to see each color easily and gives me immediate access to each marker, since timing is very important in this method of painting.

I never use an individual color by itself in a painting—except black—since most dyes are too garish or excessively showy by themselves. Every color in a painting is a combination of two or more hues mixed together. Sometimes I place as many as four colors on top of one another in my color fields. Being proficient at this comes with experience.

The dye colors I incorporate most often in my painting are from black dye markers. This statement may sound incorrect, since black is not considered a color, but the majority of black dye markers differ from other color markers in that each brand displays a different variety of colors when placed on rice paper and when water is applied. Black markers contain as many as five different dye colors; adding water causes their dispersion. As an example, a Mr. Sketch marker contains various shades of yellow, blue, purple, pink, and brown. A Sign Master marker displays several shades of green, red, and purple. Few black markers contain only black dye. One of

WATERCOLOR DYE MARKERS

BLACK DYE MARKERS CONTAINING A VARIETY OF HUES

DR. MARTIN'S TRANSPARENT WATERCOLOR INKS

TRANSPARENT WATERCOLOR INKWELLS AND MIXING DISHES

these is a Magic Marker with a white cap. A Magic Marker with a black cap produces a variety of colors in the green and purple range.

The advantage of using black markers with their individual qualities and varieties of color is that one can use them alone, without the addition of any other colors, or in combination with other single-color dyes. When they are used in conjunction with individual one-color markers, they enhance and change the color significantly. For this reason, I use black markers extensively in my work. They produce a complexity of color that cannot be achieved in any other way with any other painting medium.

TRANSPARENT WATERCOLOR INKS
What I refer to as transparent watercolor inks are usually sold under the name of transparent liquid watercolors. Being in a liquid form, transparent watercolor ink has its own limitations. When several watercolor inks are placed on a sheet of rice paper, they immediately flow together. By contrast, dye marker colors can be superimposed on one another without extensive bleeding.

One of the reasons I use watercolor inks in conjunction with dye markers is to emphasize their differences. Dye colorants have the characteristics of being airy, delicate, and remote, whereas watercolor ink is vivid, powerful, and immediate. The two mediums complement each other with their contrasting personalities and qualities. The ink causes the dye colors to appear more distant and vague, and the dye

colors make the inks appear to be in the foreground.

The application process for watercolor ink is similar to that of watercolor paint in that it is normally placed by brush directly on either dry or moist watercolor paper rather than first being bled through rice paper, as is the case with dye colors. The difference between ink and tube paints is that the ink spreads in a more violent, explosive manner when it is placed on a moist paper surface, and it has greater color intensity. Another attribute of watercolor ink is that it is susceptible to bleach. A small amount of Clorox will alter the colors, and a fifty percent solution will eliminate the color altogether. This is a luxury that tube watercolors do not offer.

There are more than one hundred distinct hues of watercolor inks. They can be purchased in either half-ounce or two-ounce bottles. I have a large collection of Dr. Martin's transparent watercolor inks, which have proven to be of high quality and excellent durability. A watercolor ink palette must have deep wells to separate the fluid colors and a flat open area on which to mix the colors. Dried inks become usable again with the introduction of water.

LIGHTFASTNESS OF DYES AND INKS
Some artists are reluctant to experiment with or to incorporate dye or ink into their paintings because of the shorter lightfastness of this medium as compared to watercolor tube pigment. If a painting executed in transparent watercolor paint is exposed to direct sunlight over an extended period of time, the

colors will begin to fade, and the painting will appear to be washed out. If a picture painted with dyes and transparent watercolor inks is subjected to the same sunlight, it will begin to deteriorate at an even faster rate. This differentiation of durability between the painting mediums can be partially corrected by the selection of quality light. By keeping a painted surface out of direct sunlight and direct artificial light sources of all kinds, you can achieve a maximum period of lightfastness. (See Part IV for a discussion of preparation, hanging, and storing of paintings.)

The somewhat shorter life span of a dye or ink painting should not deter an artist from using this medium. I firmly believe that the quality and intensity of the artist's personal expression override the question of durability. In any case, one can always make color reproductions and color slides of his works. I myself cannot sacrifice quality of expression to achieve a second-rate painting that might have a somewhat longer life span. A number of my paintings are over twelve years old, and they bear little change in color quality.

Recently, a material called Print Guard has been developed; it can be placed over a painted surface or secured to the glass in a frame. This material can be adhered to surfaces either by pressure-sensitive or heat-sensitive means. Photography laboratories have equipment for this laminating process. Print Guard will filter out a good percentage of the ultraviolet rays from the sunlight, thus protecting the sensitive surface of a dye and ink painting. This product is produced by Seal Products Incorporated, 550 Spring Street, Naugatuck, Connecticut.

RICE PAPER

Handmade Japanese paper, called *washi*, at one time was of high quality; it reached its peak in the mid-1800s. This was before Western influences, such as paper machines, were introduced. Today, much of what is called Japanese rice paper is produced mechanically and is chemically bleached. If the paper has color, it comes from chemical dyes rather than from natural colored fibers. That is not to say, however, that authentic handmade papers are no longer being produced. Some Japanese rice paper makers still carry on ancient methods of paper making.

The name *rice paper* is misleading, since most Japanese paper is made from cooked wood fibers.

Today, rice has nothing to do with Japanese paper. There are many brands and qualities of so-called Japanese rice paper. Some have more coarse fibers in them than others; some are heavier in weight than others; and some have a greater degree of whiteness than others.

If the paper has longer, more dense strands of fiber running through it, these fibers will tend to absorb color faster than the nonfibrous areas, thus causing the dye colorants to disperse in a rather sporadic manner. If the paper is refined and has a smooth body to it, the color will spread in a much more predictable pattern.

I use a paper called Sketch Paper by Yasutomo and Company. It has a smooth side and a more textured side. Even though the paper is not sized, the smoothness or slickness of the one side allows me to pull the dye markers onto its surface without tearing the paper. I have found that its uniform quality and greater whiteness provide an appropriate surface for painting with colored dye markers.

WATERCOLOR PAPERS

Three important factors are involved in the selection of the best watercolor papers for dye paintings: surface quality, whiteness, and weight. The surface of any watercolor paper should always complement the medium you are using. In the case of dye colors, with their delicate qualities, filmy transparency, and iridescent intensities, a smooth paper surface works best. A more textured surface competes with the sensitive qualities of the color.

The whiteness of the paper is also of great importance. The paper's surface has to be immaculately white for every nuance of color to be clearly seen. Any darker value would reduce the brilliance of the dye colors and destroy the subtlety of the washes.

Because of the extreme liquid, wet-on-wet approach of my technique, I normally use a paper with great strength (about 300-lb.), which will not buckle or allow rivulets of color to run across the surface during the painting process. You can use a paper of at least this weight without having to adhere it to a board.

After experimenting with many watercolor papers, I have found two surfaces that meet my requirements best: One is a hot-press, 300-lb. Italian Fabriano paper, and the other is a museum-grade,

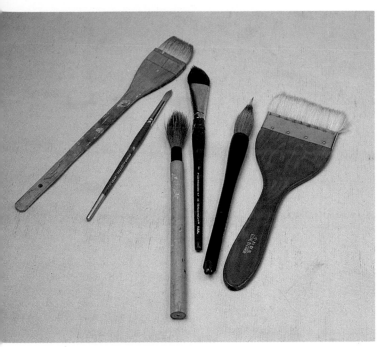

CHINESE, JAPANESE, AND GRUMBACHER BRUSHES

hot-press 100 percent rag mat board. The mat board has the whitest of all surfaces, and it will not buckle regardless of the amount of water applied to it. Though these papers are somewhat more costly than others, they best display the sensitive nature of dye and inks and pay the highest compliment to their various hues. Some heavier hot-press Arches and Strathmore papers can be used with some success.

BRUSHES

I use a number of large round pointed Chinese, Japanese, and Grumbacher brushes. Some of the flat-edged brushes are as wide as four inches. I use large pointed Japanese brushes to apply water to watercolor paper surfaces and also to the dye colors placed on the Japanese rice paper. One of the brushes that I use most is a Joto Series 700 brush. This can be purchased at pottery supply shops and art supply stores. I use smaller pointed sable and camel hair brushes for adding details, such as tree limbs, in watercolor ink. Pointed synthetic brushes work well for applying a bleaching agent to areas of color because bleach burns camel hair or sable hair, rapidly destroying expensive brushes. These synthetic brushes can be purchased at most art supply stores and are less expensive than natural hair brushes.

ADDITIONAL PAINTING TOOLS

Hair Dryer. Because of the rapid spreading tendencies of dye and watercolor ink, the hair dryer is a very important tool. In my painting method a number of steps have to be completed almost simultaneously if the painting is to survive. At one point, the drying process has to be shortened. At another point, drying has to be retarded so that certain shapes can expand and certain colors can fully mix.

If a dye or ink color is allowed to spread and dry at its own rate, much of the intensity and value of the color can be dissipated and certain desired forms dispelled. Controlling the drying time can mean the difference between the success and failure of a painting. Having a hair dryer with several speeds allows for both a slower drying time and a faster one. But you must remember to use caution in placing the dryer at an appropriate distance from your work. If it is too close to the moistened surface, the velocity of the air will cause the medium to run in rivulets or to leave color ridges where the color is concentrated by the flow of air.

Slide Viewer. Another important piece of equipment to have is a Simon 8″ × 8″ slide viewer. This viewer allows me the advantage of seeing a 35-mm slide clearly in a lighted room. I am able to continually refer to the subject matter while executing the painting rather than projecting the picture on the screen while the lights are dimmed or turned off. The slide viewer has a magnifying feature that enlarges small sections of the slide to many times their normal size. This allows me to study color intricacies in rather obscure areas of the landscape.

Sponge. A large elephant-eared sponge is a necessity in executing paintings using dyes and inks as the colorants. Often there is a need both to sop up excess moisture and to apply more moisture to the watercolor paper surface. The shape and pliability of this sponge lend themselves to fulfilling these needs. You can also use this sponge to apply color to the surface of the paper by dipping it into a well of prepared watercolor ink and daubing it on the painting. This method works well when you need foreground textural details, such as ground cover or rock surfaces. A quality sponge is well worth its cost. Synthetic sponges are limited in their water-holding capacities and crude when used to apply color.

EXPLORING DYE MARKER COLORS

When you first experiment with dye colors, you may be surprised by the interesting characteristics of the medium. Its unpredictable, explosive, delicate nature, and its fascinating ability to alter the hue, value, and intensity of other colors are great advantages in painting with this medium.

You need to develop some skill in mixing various colors if you want to become proficient in this process. Sometimes you'll want a complete mixture in several colors; sometimes only a partial one.

The best place to begin this new experiment is to produce a systematic chart of color combinations, together with notes that identify the positioning of the various colors in relation to one another. When I make a collection of various colors, I always begin by placing a small circle of dye from a marker or from several markers in the middle of a sheet of sketch paper made by Yasutomo and Company. I then place several drops of water from the tip of a watercolor brush or a medicine dropper onto the area of dry color. This water causes the dye concentration to spread dimensionally and helps facilitate its separation into various color components. When the moistened color circle has expanded to about three inches in diameter, I use the hair dryer.

Once the colored circle has dried, you must protect it from further moisture, since a new drop of water will penetrate the original color and leave a new, smaller inner circle. The center of the new circle will be light in value with a dark rim. This is caused by the water displacing the original color and pushing it out from the center to form a concentration of color at its edge. Since dye colors do not ad-

here permanently to watercolor paper or rice paper, they are subject to alteration by the addition of the smallest amount of moisture.

You should label each mixture of color with regard to the various markers used in its production. You can refer to these colored shapes in the future when you need a certain color for an area of painting. When you are making a color chart, notice that there is a slight separation of the various color components in each individual dye color when the color is placed on a dampened piece of rice paper.

When two or more colors are superimposed on one another, normally only a partial mixture of the colors occurs when moisture is applied. This limited mixing is advantageous in that the colors in transition often suggest some aspect of nature such as an area of vegetation, soil, or rock formations. Sometimes I will place as many as four colors on top of one another before applying water to mix and disperse them. A multiplicity of color is the result of such mixtures.

Since each color marker is so intense when used alone, I will often place a few marks from a black marker on the color to make it more complex and more earthy. Obviously, black affects each color differently; experiment to determine the amount and kind of influence the black marker, with all its hidden colors, will have on the original hue.

Color combinations are without end when you are joining several dye colors together. But I find that there are a few color combinations I continually rely on in my paintings. This will be discussed in a later chapter in the painting demonstrations.

Black Markers

DRY BLACK

MOIST BLACK WATERCOLOR CONCEPT

MOIST BLACK MR. SKETCH I

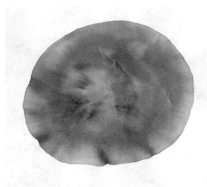

MOIST BLACK MR. SKETCH II

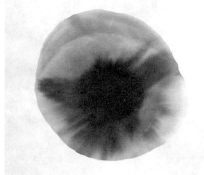

MOIST BLACK VIS-À-VIS

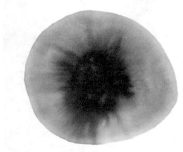

MOIST BLACK LIQUID CRAYON

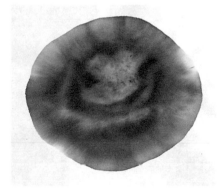

MOIST BLACK SIGNMASTER

MOIST BLACK MARVY BRUSH

MOIST BLACK WEAREVER WHALE

RED

GREEN

YELLOW

PURPLE

BLUE

ORANGE

Marker Colors Mixed with Black

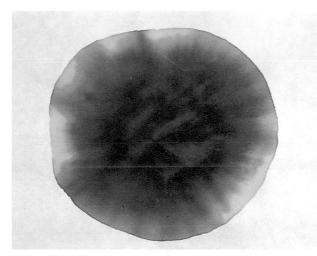

RED WITH BLACK

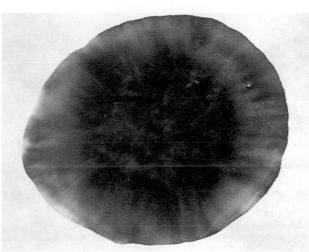

GREEN WITH BLACK

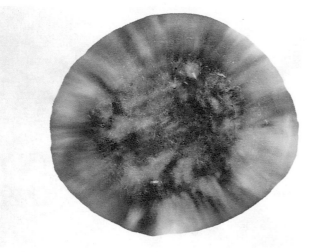

YELLOW WITH BLACK

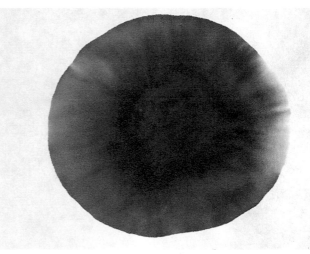

PURPLE WITH BLACK

BLUE WITH BLACK

ORANGE WITH BLACK

Miscellaneous Marker Color Combinations

RED AND BLUE

RED AND YELLOW

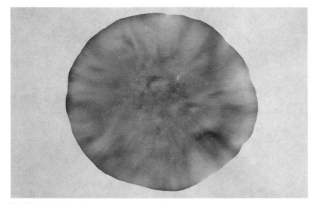

BLUE AND YELLOW

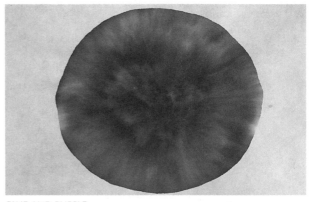

BLUE AND PURPLE

MAGENTA AND GOLD

PURPLE AND ORANGE

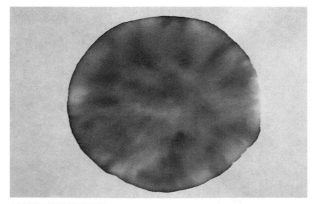

VIOLET AND YELLOW

RED AND GREEN

PURPLE AND GREEN

YELLOW AND YELLOW GREEN

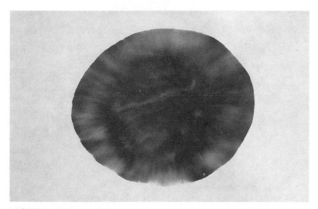

VIOLET AND ORANGE

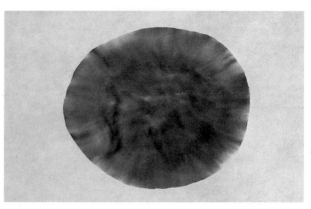

BROWN AND YELLOW

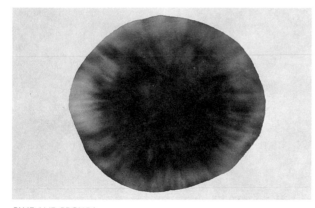

BLUE AND BROWN

YELLOW AND TURQUOISE BLUE

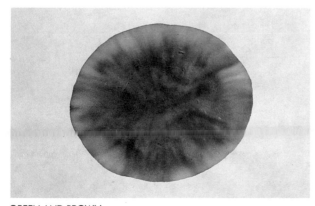

GREEN AND BROWN

PURPLE AND BROWN

19

ALTERING COLOR WITH WATER AND BLEACH

Using the bleaching agent Clorox as a tool when working with dyes and watercolor inks is both a necessity and an advantage. Sometimes a color must be lightened or changed. At other times, a portion of a color has to be totally extracted from the surface of the paper. Such flexibility in painting a watercolor is a real luxury, since Clorox has little effect on watercolor tube pigments. Because of this, I feel watercolor pigments alone are more limiting to the artist who wishes to make an addition or deletion after the surface of the paper is completely dry.

Even with the help of the bleaching agent in painting with dyes and inks, the artist should carefully plan the painting and execute the methods with skill and foresight in the reserving of white space. Sometimes mistakes are unavoidable with so fluid a medium. When they do occur, you can correct them with bleach solutions of various strengths.
About one part bleach with five parts water will lighten a color; one part bleach with three parts water will change the original color; and a stronger solution of Clorox will completely lift out most colors. Experiment with this technique to gain some consistency in control. If you use a good grade of paper in your painting, bleached-out areas will be receptive to new color additions.

A second bleaching agent of importance is water itself. Once an area of dye color is dry, it is susceptible to change by the addition of more water. Because dye color and watercolor ink do not bond permanently with paper, they are easily moved from one place to another on the paper's surface by further moistening the colorants. The amount of water added to a dried area of color determines the degree of value change in the color. You must watch over this method of color change carefully, since large areas of a painting can be destroyed if this new moisture is not strictly controlled in terms of application of the water and drying time.

BLACK SIGNMASTER DYE ON TEXTURAL LONG-FIBER RICE PAPER

WATER DROPLET ON BLACK DYE—MR. SKETCH I

WATER DROPS ON BLACK SIGNMASTER DYE

WATER DROPS ON BLUE DYE

WATER DROPS ON A MIXTURE OF RED AND BLUE

THREE PARTS WATER WITH ONE PART BLEACH DROPPED ON BLACK DYE

ONE PART WATER WITH ONE PART BLEACH DROPPED ON BLACK DYE

EXPERIMENTING WITH TRANSPARENT WATERCOLOR INK

When you compile a collection of ink color mixtures, you need a different approach than you used when experimenting with dye color. Since rice paper is so porous, owing to its lack of sizing, the paper need not be moistened prior to ink applications. The fluid state of the color will carry it across the surface of the paper to mix with any other colors you apply.

If lighter values of colors are desired, the rice paper can be moistened before the ink is placed on its surface. The water in the paper will dissipate the ink, thus reducing its intensity and value to a degree. Though watercolor ink will disperse at a somewhat faster rate when placed on a dampened piece of rice paper than a dry piece, the degree to which it spreads is much less than that of a dye marker placed on the same moist piece of paper. Because of this, watercolor ink is best used for painting more recognizable elements in nature, such as middle-distant and foreground groves of trees and hills rather than undefined background washes. Watercolor inks can be used in conjunction with dye marker colors if they are applied to the rice paper while the surface is still damp. The absorbing qualities of the rice paper give a greater degree of control to the artist using ink, which bleeds much less freely than markers do on this surface.

Several shades of green watercolor ink were painted onto a moistened sheet of rice paper using a small brush. As the moisture began to dry, darker shades of green were applied to the foreground pines, revealing more of their three-dimensional qualities. Before the rice paper was completely dry I painted several earth colors in front of the trees.

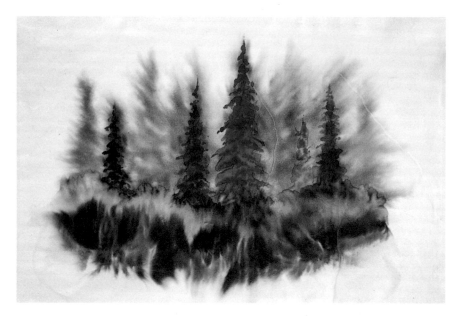

Two watercolor ink bushes were painted on a dampened sheet of rice paper. Beginning at the top, I painted a light yellow-green color that grew progressively darker as it moved down the bush, suggesting sunlight and shadow.

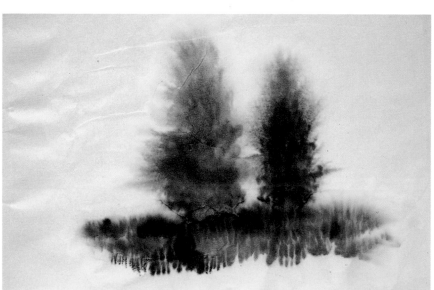

After mixing blue and yellow transparent watercolor inks, I brushed the colors onto a sheet of dry rice paper. A slight spreading takes place, and then the two original hues begin to separate at the outer edge of the color circle.

Moisture is applied to the ink spot with a brush, which causes the color to expand and separate more dramatically. Because rice paper won't retain the mixed colors, this ink process is difficult to use in rice paper landscape painting.

A brush is used to apply a mixture of yellow ochre and burnt orange directly onto a dry sheet of watercolor paper. I often use this method of painting for putting in foreground details

I mixed olive green and cerulean blue ink and brushed it onto a sheet of damp watercolor paper. The explosion of vibrant color that results lends itself to painting various types of vegetation in a landscape.

Watercolor Ink Color Combinations

ULTRAMARINE BLUE AND YELLOW

PURPLE AND YELLOW

BURNT SIENNA AND CADMIUM YELLOW

VIOLET AND CHROME YELLOW

VIOLET AND RED

VIOLET AND BURNT SIENNA

MAGENTA AND CADMIUM GREEN

VIOLET AND ORANGE

ORANGE AND CERULEAN BLUE

SEPIA AND CERULEAN BLUE

GREEN AND VIOLET

LIGHT GREEN AND ORANGE

PAYNE'S GRAY AND YELLOW

BURNT SIENNA AND CERULEAN BLUE

WATER DROPLETS ON DRIED INK

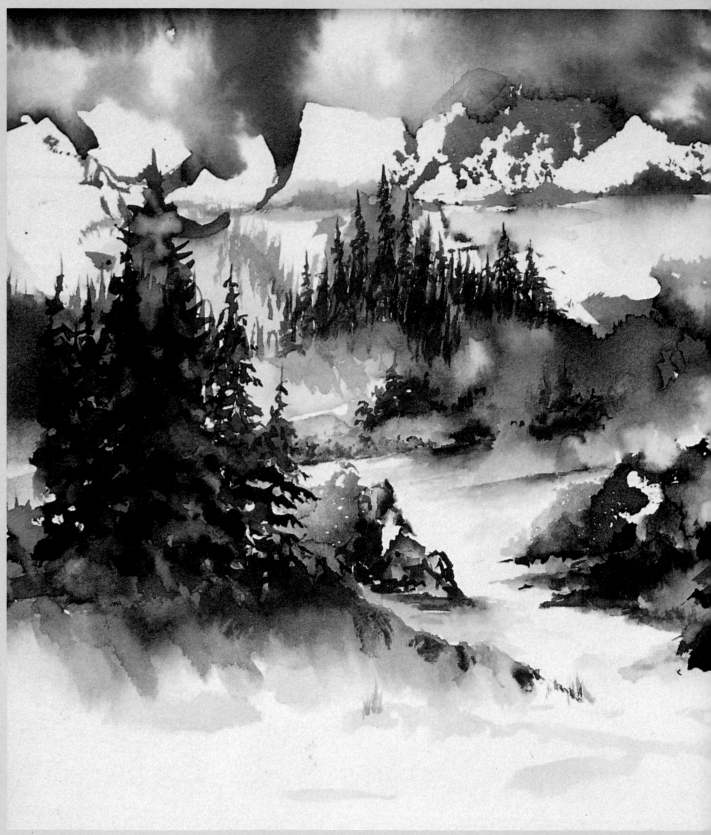

WINTER LOCKUP, dye color and watercolor ink on watercolor paper, 12″ × 16″ (30.4 × 40.6 cm).

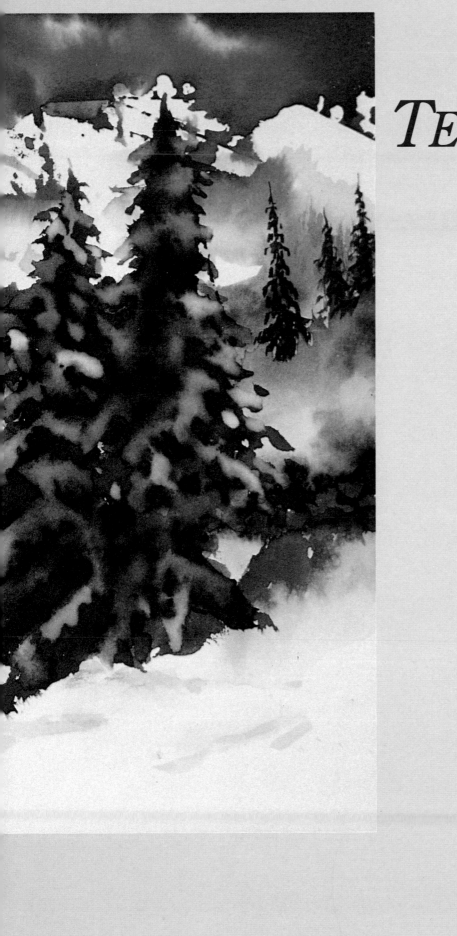

Part II
BASIC TECHNIQUES

WORKING DIRECTLY ON RICE PAPER

There is less detail and clarity of line when finalizing a painting on rice paper because of its extreme porous nature, but there are kinds of expressions that cannot be duplicated when using any other paper surfaces. Though I use rice paper most often as a vehicle to transfer dye from a marker to the surface of watercolor paper, I will often complete a painting on the rice paper itself.

When dye colors from markers are placed on dry rice paper and later water is applied by brush, the dye colors will disperse very rapidly, and usually in a circular shape, as the color exercises on pages 15–19 showed. The colors will be more intense, more varied in hue, and darker in value than when the same color combinations are bled through rice paper to watercolor paper.

From my own past experiences using rice paper as the ground for painting, and from observing others in my workshops, I can say that it will take several tries before a sense of success can be achieved. I believe that the best way to begin experimenting with this technique of color application is to use pieces of rice paper no larger than 8 inches by 10 inches. This smaller surface will reduce the number of elements that must be controlled to create a successful painting. As you gain some confidence in working with the medium, you can try larger and more complex paintings.

I invented these ways of working on Japanese rice paper not for the sake of showing just how many ways you can use to build a painting or to show a variety of techniques valuable in and of themselves. I developed the method to provide a means to express my emotional responses to nature. Since the mood swings of nature are so varied—sometimes clear, sometimes hidden—having a number of options to portray ambiguity is a luxury for an artist. But the techniques employed in painting any given landscape must always serve the meaning and emotional impact of the finished work.

If the first application of color to the rice paper is allowed to dry at its own speed, most details, such as trees, hills, and rocks, disappear as the medium rapidly spreads across the surface. You can preserve these elements of nature if you dry the paper with the hair dryer soon after you've painted them into the picture. However, this limits the complexity of the painting because only so many details can be included before they begin to fragment with the swift-moving moisture. I make it a practice to include only those details I can comfortably manage with each application of water. I try to work from top to bottom so I don't disturb the previous layer of color.

The biggest difficulty in working directly on rice paper is timing. Since the paper spreads the color so rapidly and absorbs it so quickly, completion time for the entire picture is short. Not only is an overall time limitation imposed on the painter owing to the absorbency of the rice paper, but other aspects of timing come into play, concerning the placing of additional colors at the precise time and applying certain amounts of moisture at the correct moment and in the right place. The painting will succeed or fail, depending on the artist's timing in applying color and moisture and his control of the drying time. More textural rice paper will tend to push color along its fibers and give the effect of some details of nature as opposed to the smooth, even-fibered papers that lend themselves to producing softer, more distant effects. The type of rice paper you select makes all the difference in how a painting will look.

SINGLE APPLICATION OF WATER

Since the amount of water applied to the dye colors plays such an important role in determining the outcome, you need to be particular in your choice. Some expressions call for a rather wet approach, whereas other effects are achieved by moderately dampening the paper. It depends on the desired clarity or ambiguity you want in your painting. There are a number of ways to apply water, depending on the effects you want. It is relatively easy to place a large amount of water onto the rice paper with a large, broad brush, but it is more difficult to restrict the amount of moisture. For example, if I need to cover a large area with a small amount of water, I first dampen a clean sheet of rice paper and place it on top of the paper carrying the color. I then pull a wide brush across the dampened rice paper to press the moisture onto the painting. This limited application of moisture allows the color to spread much more slowly and limits its expansion.

I use this method of moisture application when I desire to retain nature's individual elements as separate entities rather than making a unified statement produced by blending the elements in a more diverse manner. Reducing the amount of water used to blend and disperse the dye colors darkens the value and heightens the intensity of the painting, whereas adding moisture dissipates the color.

If you want the painting to be impressionistic, seek to complete every aspect of it before the first and only application of water has dried. This approach results in a soft atmospheric image, as each color and shape begin to blend into one another, leaving no hard edges or distinct shapes. Of course, you have to stop the blending of the elements with the hair dryer at the right time or the painting will expand to the right point where it loses all its recognizable shapes.

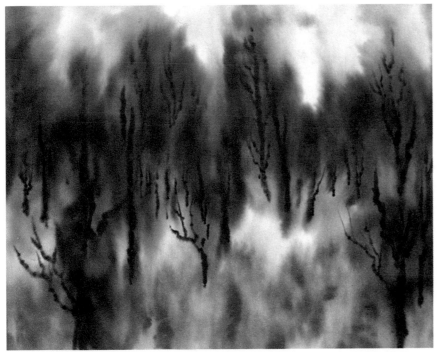

TREE IMPRESSIONS, dye color on rice paper, 10″ × 12″ (25.4 × 30.4 cm).

I completed this group of trees with one application of moisture. After drawing several shades of blue onto the rice paper to represent trees, I placed yellow and brown color on the lower part of the picture to represent ground cover. With a wide hake brush, I drew water across the surface of the rice paper. When the images appeared during the dispersement of the water, I used a hair dryer on the painting.

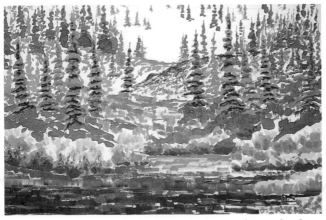

I used a variety of colors from dye markers to draw a landscape directly onto dry rice paper.

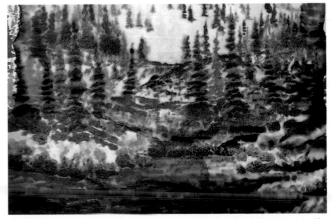

With a four-inch brush, I placed an application of water on the rice paper. As soon as the moisture began to blend and bleed the colors, I quickly dried the painting with a hair dryer. The painting can sometimes be reworked if the results are not acceptable. But often it is irretrievable.

WORKING ON DETAILS

When the details of the picture are to have more independent importance, you can do the painting in several steps with several drying periods. You would paint the sky area and let it dry before adding a distant mountain range. Middle-distant space would have to be painted and dried before you add the foreground colors and shapes.

Working with this technique is more difficult because once the first color application has dried, the second application cannot help but change the original color or the various shapes. Usually you have to place succeeding colors below previously dried areas so that you can control the height of penetration as the colors move upward.

Another way of working with dye on rice paper is to combine dry and wet methods. When a rather impressionistic painting is almost dry, use dye markers to draw directly into the painting. The slight moisture left in the rice paper will allow the marks from the marker to soften while retaining a rather clear separation from the surrounding image. When I want a separation of elements while retaining an overall sense of image, I use this approach.

After forming a light sky area by transferring color from one piece of colored rice paper to another, I drew a black line with a Mr. Sketch black marker.

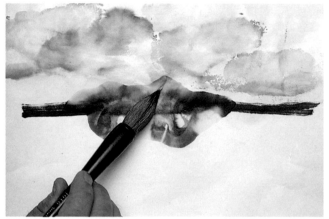

Using a small brush saturated with water, I placed moisture beneath the black line. The water separated the dye into its various hues and pushed it upward to form mountain peaks. When the planned height of the mountains was reached, I dried the paper.

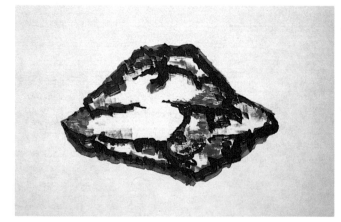

I drew a rock form on rice paper with black and brown dye markers. I made the drawing smaller than the size I desired, knowing that the rock would greatly expand when I added water.

With a wet brush, I blended the dye colors together and pushed the rock form into the desired shape. Then I quickly dried the area.

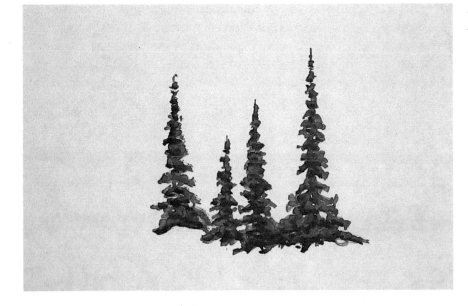

First, pine trees were drawn with black, green, and blue markers.

As you can see, the amount of moisture and the drying time allowed by the painter affect the subject matter spatially. Here, water was sprayed onto the paper and allowed to dry at two time periods.

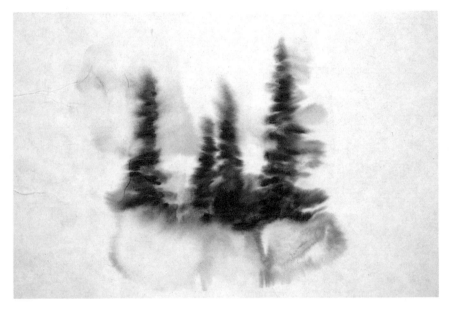

If the water dried with no assistance by the painter, the trees would become indistinguishable.

USING A SPRAY MISTER

A spray bottle is a valuable tool. The fine droplets of water break up dried pigment to create texture. When painting foliage, for instance, apply a spray of water after the first coat of color is dry to give a sense of multiple leaves. When painting rocks, spray more freely so the color runs, forming crevicelike effects. Gently spraying the image of a still lake gives a shimmering effect. For dramatic skies, place dye colors at intervals on the paper and spray with water to create cloud formations. When color areas do not spread as fast as you wish, spray more water on the shapes while the paper is still damp from the first spraying.

To achieve some sense of detail on distant vegetation, I sprayed drops of water onto previously dried foliage, holding the spray bottle approximately three feet from the rice paper. The area sprayed has to be dried immediately in order to retard the formation of spray droplets.

To paint a sunset, I applied black dye marks at various intervals across the upper half of the rice paper, and pink, yellow, and orange marks across the lower portion. Then I sprayed water onto the paper with a mister to mix and spread the colors and let the painting dry in its own time. When the surface was completely dry, I drew a black line at the lower edge of the paper and pushed the color up with a moistened brush to form a mountain range. When the peaks began to penetrate the lower portion of the sky and there was a reflection of the light on the mountains, I dried the painting.

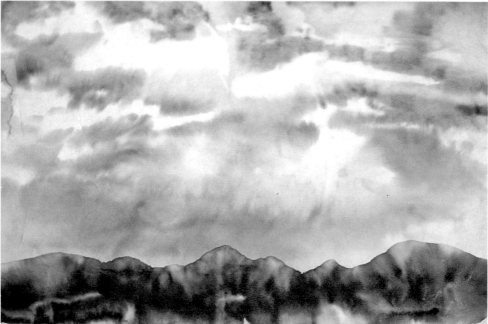

Beginning with the lightest values highest on the picture plane and the darkest in the lower foreground, I used several shades of blue dye markers on a sheet of rice paper. I pulled a broad moist brush across the surface of the colored rice paper sheet to fuse the colors. When the color had dried, I sprayed a fine mist onto the rice paper to form small separations of color that made the water shimmer.

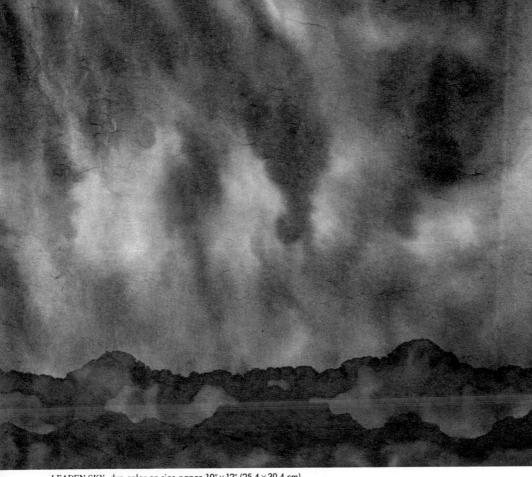

LEADEN SKY, dye color on rice paper, 10″×12″ (25.4×30.4 cm).

By placing black and brown dye on rice paper, I created a leaden sky. Then I sprayed water onto the color, allowing it to spread and blend at its own pace. At the bottom of the painting, I drew a black, orange, and brown dye color line. I began by placing water beneath the line with the brush, allowing it to rise upward until a dark mountain range appeared. Then I dried the paper. This small painting confirms my belief that it does not take a multiplicity of forms to create a successful landscape. An extremely atmospheric mood using a limited number of images can make a potent statement.

MANIPULATING LINES OF COLOR

When painting a distant mountain range, I start by drawing a black line across the paper about one-third of the way from the top using a Mr. Sketch marker. With a pointed brush, I then place water beneath the black line. Where the mountain peaks are to be higher, I add more moisture and push the color upward. The point of the brush releases the water, while the base of the brush, pressed onto the paper, traps the moisture so only a limited amount can spread downward. As the color rises it becomes lighter, causing the mountains to appear to recede.

If you want an area of color to have a definite hard edge, apply the water below the area of dry dye color. When you want a soft, transitional effect, as for clouds or distant foliage, first place a small amount of water above and at some distance from the color areas. Then quickly place a larger amount of water directly under the color, pushing it upward toward the premoistened area. When the spreading dyes reach the moistened paper above them, they will diffuse in many directions, producing the desired effect. With practice you can achieve some control over the direction of the spreading color.

After placing a light sky color on a dampened portion of the rice paper using a Mr. Sketch marker, I then used dye markers to draw lines in preparation for a landscape painting that would be completed with one application of water. I used a black Mr. Sketch marker to draw a line for the mountain range. For the lake, I worked with three shades of blue. Green, brown, yellow, orange, and black made up the foreground vegetation and ground cover.

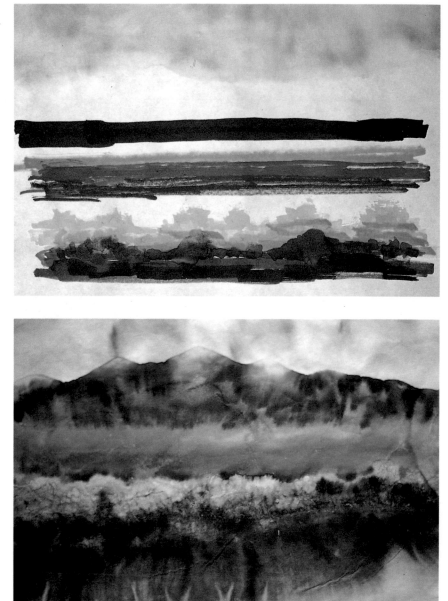

Between the black and blue lines I applied water with a brush. Pushing the mountain peaks upward, I created a hard edge at their summit, then added water beneath the foreground color, pushing the color toward the upper moistened paper. When the dye reached the previously moistened area, it diffused into shapes suggestive of several types of ground cover or foliage. When the images attained maximum readability, I stopped their diffusion with a hair dryer. Details such as pine trees were added with a small dye marker when the painting had dried.

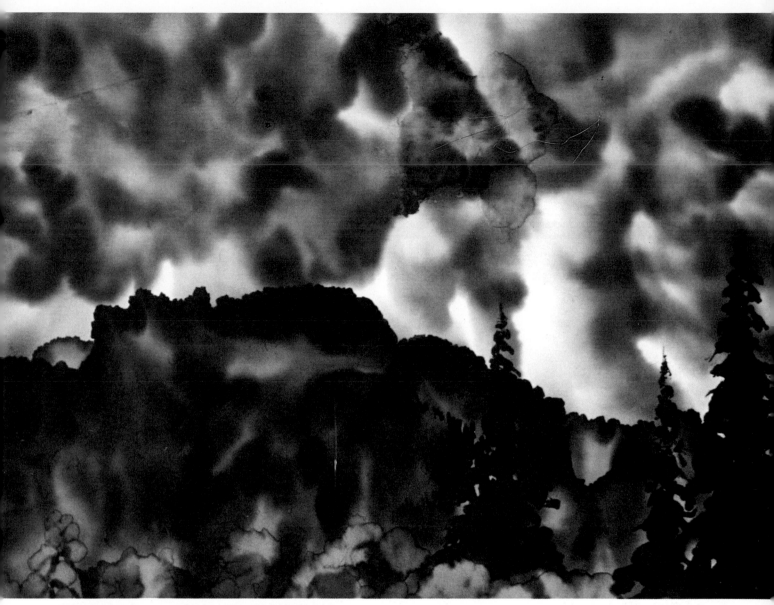

HEAVY SKY, dye color on watercolor paper, 10" x 12" (24.5 x 30.5 cm).

I placed black marks from a Mr. Sketch dye marker indiscriminately across the upper two-thirds of the rice paper. With a wide brush, I drew a slight amount of moisture across the color. The limited amount of water ensured a slower spreading rate for the dye and a darker value for the sky. When the sky wash was dry, I placed a one-inch black line just above the bottom of the painting and a series of yellow marks along the bottom edge of the paper. I added water to the middle of the black line and allowed it to move upward to form the crest of the mountain. Then I placed water at the bottom of the paper to push the yellow color upward to meet the moisture of the mountain and take on the form of bushes. When the painting had dried, I drew tall pine trees directly into the scene using a black dye marker. Though there are but three components to this landscape (sky, mountain, and trees), its dark dramatic values create a compellingly portentous mood.

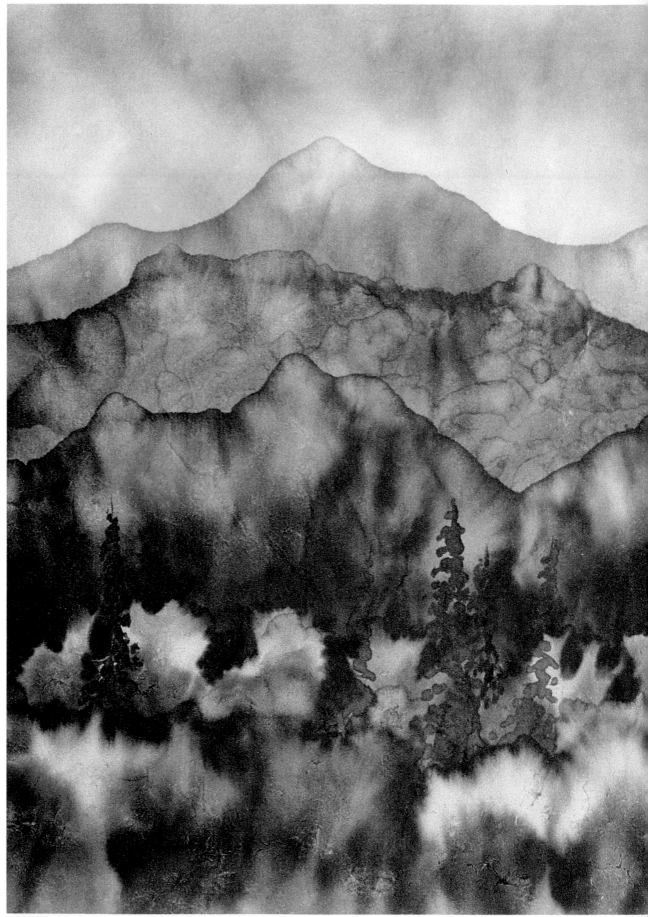

FRONT RANGE, dye color on rice paper, 12" x 14" (30.5 x 35.6 cm).

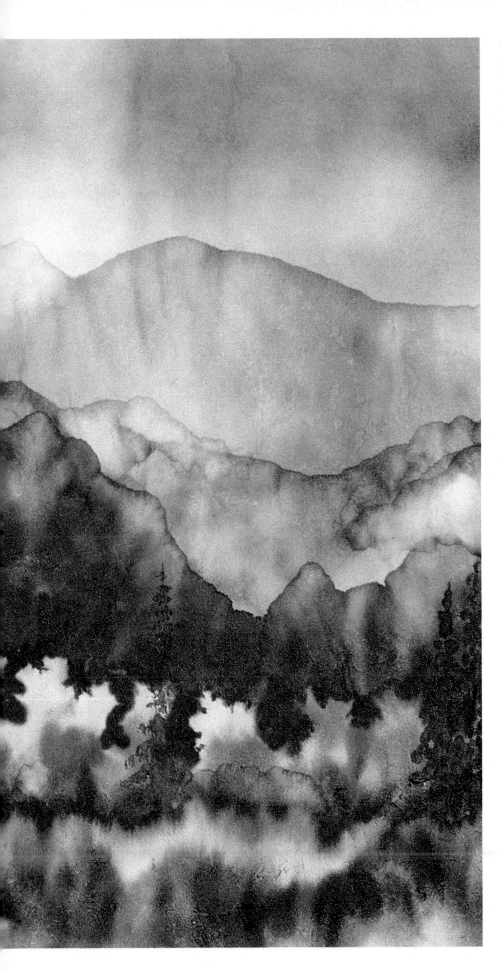

I began this watercolor dye painting on rice paper by working from the top to the bottom of the picture plane. I needed three separate stages for the painting and drying in order to record sky, mountains, and foreground.

37

ADDING DETAIL TO A NEWLY DRY PAINTING

Landscape painting often involves creating the illusion of depth and distance. When working in an impressionistic style using dye markers directly on rice paper, you more or less automatically get the soft, hazy effects of atmospheric perspective that suggest receding planes in space. But the feeling of real depth is enhanced when you delineate at least a few elements in sharp focus—typically in the foreground of the composition. The best way to achieve this is to develop the background first, then, when the paper is nearly dry, draw directly on the surface with fine-point, flexible-tipped markers to create more detailed images.

On a sheet of rice paper, I painted a vague dye-colored cliff using blue, black, and burnt orange.

Just before the paper was completely dry, I added more intense colors and more detailed images directly to the surface of the painting using flexible-tipped markers. The paper was only slightly damp, so the trees I drew in the foreground blended subtly with the background yet remained fairly crisp in definition. Note how the addition of these few, simple elements in the front of the picture plane causes the background cliffs to recede.

APPLYING A SECOND COAT OF WATER

Try to finish every detail of your picture on the first color and water application when you use this technique. If you add details or redo an area once the color has dried, you might destroy your original colors and shapes. Since it is so difficult to achieve one's goals on rice paper completely the first time, learning to rework a painting while the paper is damp is imperative.

When you reapply water to a dry painted surface, it again mixes with bleach in the rice paper and alters the original hues. This second application of water also pushes the original color and any new color outward until the absorbing qualities of the rice paper finally stop its advance, leaving a hard edge of color in the process. But this is not to say that it is impossible to rework a painting on rice paper. It can be done.

After a painting has been completed and allowed to dry, it may appear too dark in value, too intense, or too detailed. Rather than discard the painting, you can radically change its complexity into a softer, more unified image. This transformation begins with a fresh application of water, gently applied to the entire painting. Use a wide, soft brush. When the painting softens and its parts unite into a single statement, dry it quickly with a hair dryer.

If you need a second wash in an area, you can do this successfully if you do it quickly and dry it quickly. This method will limit the penetration and formation of the color edge in its relation to the previously dried portion of the painting.

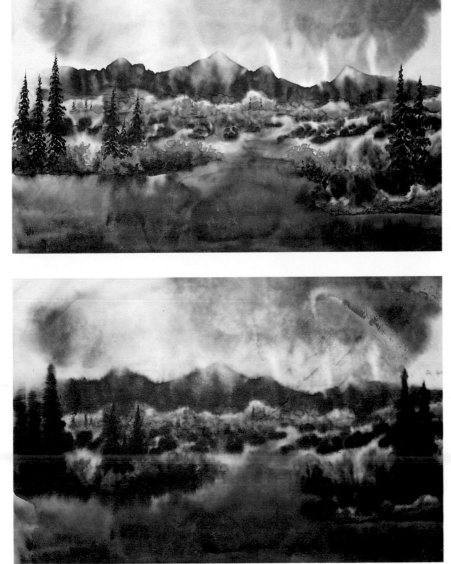

If a completed dye marker painting was not successful in its intended expression or quality of color, a second application of water can in some instances salvage the work.

Applying a coat of water to the entire surface of the painting with a four-inch brush and quickly drying it with a hair dryer transformed the landscape into a softer impressionistic image. Since there is little control of the expanding moisture, there is always the risk that certain images will disappear.

THE TRANSFER TECHNIQUE

Some of the major concerns for watercolorists are the transparency of color, the reflection of glowing light from the whiteness of the paper, the liquid diffusion of color, and the spontaneous quality of the paint application to a surface. If there is to be any virtue in using a new technique to achieve these goals, it must be in the quality of the end result. A new approach is valid only if it produces a more personal expression in any given subject matter.

In the rice paper transfer method of painting, the concerns and goals of watercolorists are uppermost. Though an artist can achieve some interesting effects by painting directly on rice paper with dyes and inks, I find that transferring the color from rice paper to various grades of watercolor paper gives a great deal more color control with regard to expansion, intensity, and value. Also, this technique affords a wider range of flexibility concerning various kinds of textural or smooth applications and is receptive to the painting of details. You will find it much easier to rework, erase, or add to an area of your painting with this transfer technique.

To achieve quality control of the details in a painting, there must first be an experimental phase to familiarize you with the basic concepts and results of transferring color in this way. The testing of color combinations provides an opportunity for such experiments.

Mountain skies are forever veiling and unveiling high mountain peaks and keeping the intensity and value of the surrounding landscape in a kaleidoscope of color. This constantly changing sky creates environmental moods that touch my emotions and cause me to respond through painting. Because of the rapid atmospheric changes, I work mainly from slides. In this painting, I sought to show the acceleration of changes in the sky after a storm—the rapid sweeping away of dark clouds followed by new light—the feeling of bathing and then drying off a landscape. I used dye colors and a light solution of bleach to form the ominous sky and distant mountains. I added the foreground details with watercolor paint.

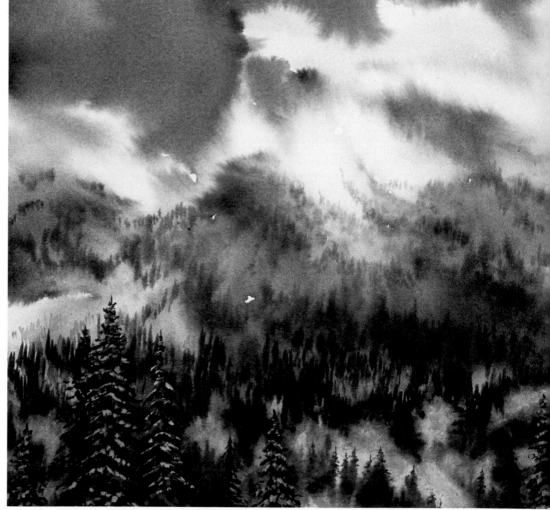

CLEARING STORM, dye color and watercolor paint on watercolor paper, 14"×16" (35.5×40.6 cm).

BASIC STEPS

Owing to the less porous nature of hot-press paper, a concentration of color from dye markers will not disperse over the paper surface if it is placed there directly from the color markers themselves. Therefore, rice paper must be used to facilitate the mixing of the colors and to disseminate them across the paper's surface. First, the colors are placed on the rice paper; then they are mixed and spread to the watercolor paper by adding water in various amounts and by using a variety of tools, such as brushes and a spray mister. The color-covered rice paper need not be placed facedown when transferring color to watercolor paper. The results of this method of transferring color will vary in direct relation to the amount of moisture on the rice paper and the watercolor paper. The greater amount of moisture, the lighter the film of color. A lesser amount of moisture produces a more intense concentration of color. Transparent watercolor ink is seldom bled through rice paper as is dye color.

When a mixture of dye colors is placed in a small area on a piece of rice paper and water is applied at its center, the colors will fuse instantaneously and be transferred to the dry sheet of watercolor paper beneath the rice paper. The transferred color will be limited in size and have a predictable shape with a hard edge.

Dye colors can be bled through the rice paper to a moistened sheet of watercolor paper with the result being an indefinite, atmospheric environment with soft edges. This technique lends itself to a vast array of impressionistic expressions, such as skies, distant vegetation, and water reflections. Though this process is spontaneous to the point of seeming to be uncontrollable, there are a number of ways to regulate the color washes. One of them is to restrict the amount of water first placed on the watercolor paper and also the amount used in diffusing the color through the rice paper. This will slow the spreading rate of the color washes and give more time to regulate the limits of dispersement by means of a hair dryer. If only certain areas of the watercolor paper are intended to be treated in a free-flowing manner, moisture must be extended only to those limits and the color restricted to those perimeters.

After applying a dark spot of color with a dye marker to a small piece of rice paper, I placed the rice paper on top of a sheet of hot-press watercolor paper.

Next, I drew water across the surface of the rice paper with a wide brush to transfer the color to the premoistened watercolor paper. This method of transfer, which disperses the color, is used to form skies and distant landscape impressions.

When you place a dye color shape on a sheet of rice paper and transfer it onto a sheet of dry watercolor paper, the color image will spread until the moisture from the rice paper is absorbed by the watercolor paper. The resulting shape will have a definite hard edge.

Dye colors bled through rice paper to the surface of a pre-moistened watercolor paper cause colors to blend and spread in a manner that produces a soft-edged image. I practice this technique when I am painting distant vegetation or cloud formations.

When dye color is bled through rice paper to a restricted pre-moistened section of watercolor paper, the color image has a hard edge on one side since the dye cannot expand beyond the dampened area of the paper. When I do not wish a section of color to bleed into another color directly below it, I use this technique.

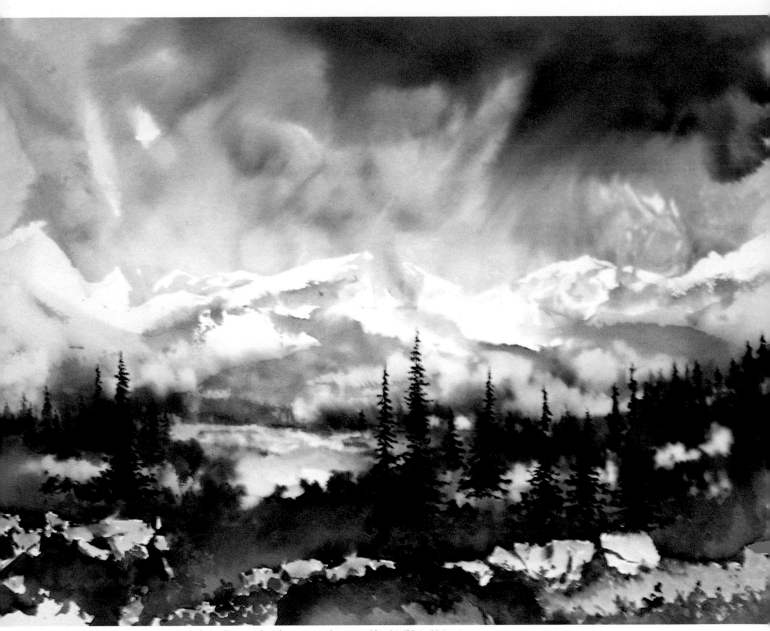

WIND RIVER RANGE, NO. 1, dye color and watercolor ink on watercolor paper, 10″×14″ (25.4×35.5 cm).

In this painting, I tried to reverse the usual textural expressions of a mountain region. Normally, the great, rising gray mountain edifices are contrasted with the soft, plush, green surrounding meadows and trees. Occasionally, however, the sky disguises the mountain in soft cloaks of mist. Foreground images of trees, rocks, and ground cover appear more textured. To paint this sky, I used several dye colors bled through rice paper. When the application was dry, I used bleach to form the mountains. Images in the foreground were painted with watercolor inks.

USING TEMPLATES

If you cut a distinct shape from a sheet of rice paper and add dye colors directly from markers, the original shape of the rice paper will be transferred if it is moistened by a small brush after having been placed on the dry surface of a sheet of watercolor paper.

Color will not extend beyond the outer edges of the rice paper shape if no moisture exists there. This transfer technique is particularly valuable for portions of a painting demanding a multiplicity of color in a limited, defined area, such as leaves, rocks, tree trunks, and flowers.

I cut a leaf shape from a piece of rice paper.

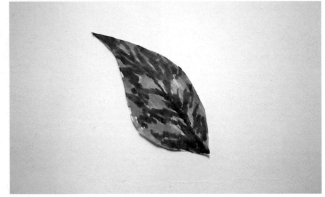

Using dye markers, I drew several shades of green onto the rice paper leaf.

I cut strips of rice paper to form the trunks of aspen trees, then pulled a black marker along one edge of the paper trunks and placed them on a sheet of watercolor paper. With a small brush, I washed the color through the rice paper onto the watercolor paper.

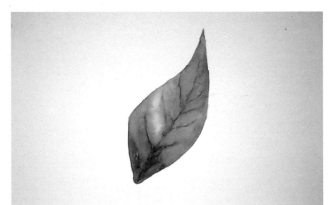

After placing the leaf on a piece of dry watercolor paper, I washed the color through the rice paper with a small brush, being careful not to allow water to spread outside the edges of the leaf shape. When I had transferred the color, I carefully lifted off the rice paper leaf.

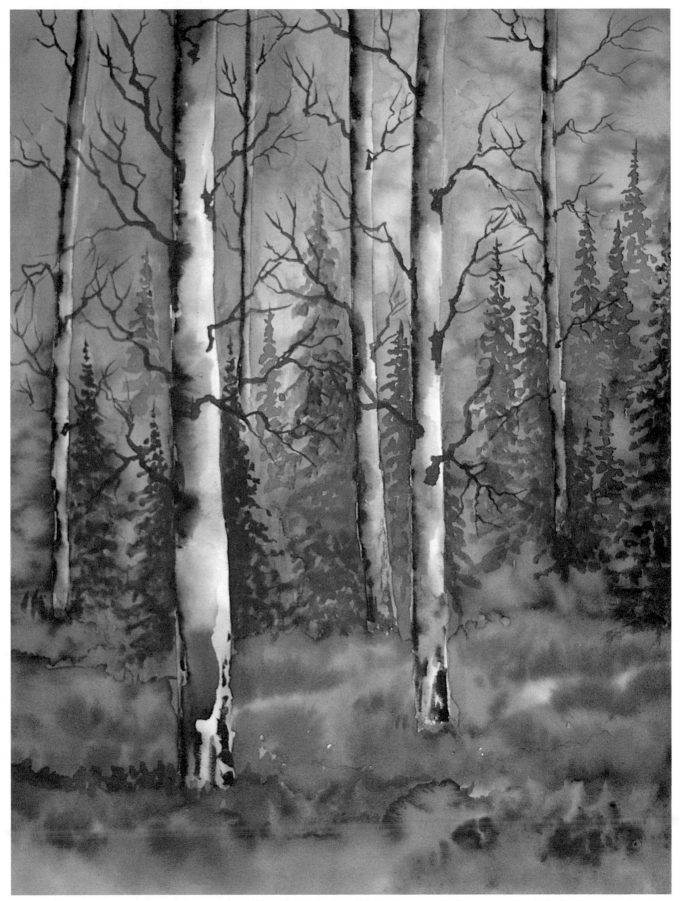

I carefully painted the background vegetation with various shades of blue, green, and yellow watercolor ink. I painted the middle-distant evergreens before the aspen trunks and limbs were completed.

TRANSFERRING COLOR WITH CRUMPLED RICE PAPER

When textural areas are needed in the painting, scraps of color-saturated rice paper can be moistened and daubed onto the dry watercolor paper. This technique is useful for creating a number of landscape images, such as distant and middle-distant vegetation, ground cover, and various kinds of rocks and rock walls.

The color and value of the small pieces of rice paper determine the identity and distance of the intended images. Light blue, gray, and purple suggest distant stands of trees, whereas darker greens appear as somewhat closer areas of vegetation. Browns, grays, and blacks can be used to create rock structures.

To produce soft impressions of more distant landscape images, moisten an area of the watercolor paper and touch the area with a scrap of rice paper that has been loaded with several colors and allowed to dry. When the dry color scrap comes into contact with the dampened watercolor paper, the colors mix and bleed across the premoistened designated area.

After drawing blue, black, and gray dye marker colors onto a piece of rice paper, I wadded the paper to form hard edges to use for creating textural surfaces on a sheet of watercolor paper.

With a spray mister, I moistened the crinkled rice paper, then daubed the paper on a sheet of dry watercolor paper. Images that were the beginnings of rock formations resulted when I added some details with a brush.

When I wanted to produce distant vegetation or distant rock formations, I daubed the rice paper wad onto a moistened area of watercolor paper. The color became lighter in value, and the hard edges softened.

Who has not been moved on seeing a mountain ridge with glacial fields that pierce a lowering sky? The power and majesty of such an experience is what I want to present in my landscapes. A mountain landscape acts as a spiritual influence that moves me to expression in my paintings. How I do this best is by using the transfer technique in my work. Here, I daubed wet color from rice paper scraps onto the dry surface of watercolor paper. The hard lines that formed emphasize the cold, stern nature of the massive rock structure.

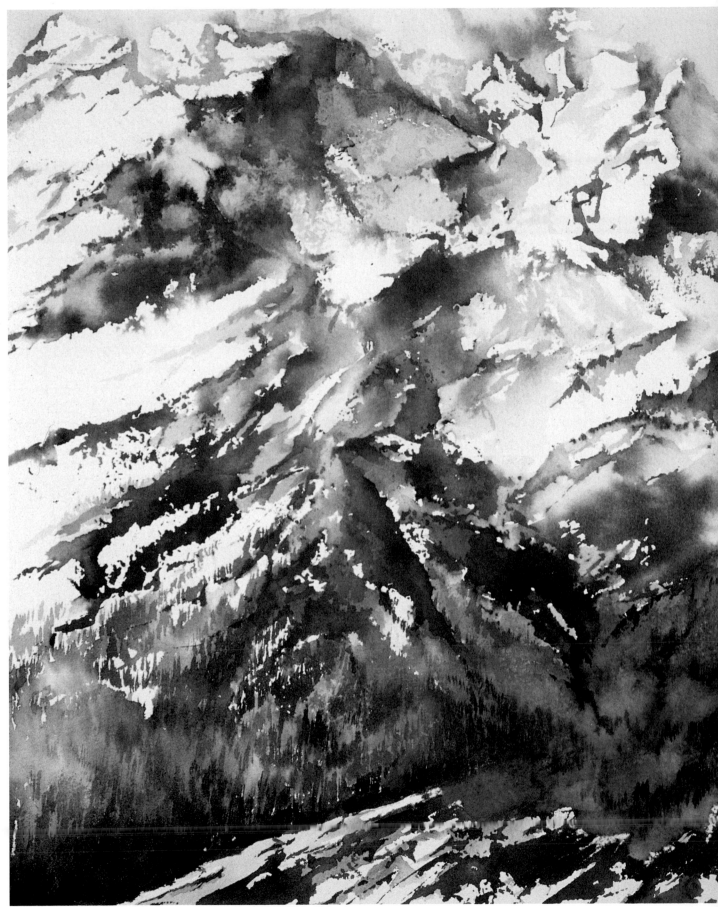

WIND RIVER CANYON, NO. 1, dye color on watercolor paper, 14″ × 20″ (35.5 × 50.8 cm).

CORRECTING WITH BLEACH

One of the most elementary instructions given to beginning watercolor students is to work from light to dark when developing a painting. In a classical watercolor, white pigment is not used since it is opaque, and when it is added to other transparent colors, it makes them opaque as well. For this reason, the light areas of the painting have to be carefully protected from the beginning of the picture so that darker colors don't invade the reserved white areas. I am certain that every watercolor artist has at some time experienced the frustration of seeing an important light value destroyed by the invasion of unwanted darker colors. When this happens, there is little you can do to correct the situation if you are using regular tube watercolor paints. Perhaps you can lift out some color by adding water with a sponge, but this means will not restore the original quality of the white paper. Some painters scrape away an area of unwanted color with a piece of sandpaper or the edge of a razor blade, but then the quality of surface is so altered that it will not receive future color without appearing very different in value and intensity from the surrounding colors.

By contrast, when you are using transparent dyes and inks, you have the luxury of restoring the white surface of the watercolor paper with a solution of bleach if an area has been lost to unwarranted color. Usually a solution consisting of one-half water and one-half bleach is enough to eradicate colors and restore the white of the paper. When this area has dried, the desired colors can be adhered with a small brush. I use this method in placing light-colored leaves, such as yellow aspens, in front of a background of dark foliage, such as firs and pines. If the area that is to be white again is of a more controlled shape, I use a synthetic brush to bleach it out. It is important to use the correct amount of bleach; if you use too much, it will tend to spread across the porous paper and the shape will be lost.

Colors transferred through rice paper can be altered in hue, value, and intensity by applying a weak solution of one part bleach to four parts water while the surface of the watercolor paper is moist. But don't let the corrective character of bleach make you careless in planning your picture. The first spontaneous expression is always the clearest and most attractive. There is never any room for negligence.

After bleeding a mixture of color onto a sheet of slightly moistened watercolor paper, I applied a weak solution of bleach and water to one-half of the color image. Changing color in this way is advantageous for creating dye color landscapes where one wants single landscape elements, such as trees or shrubbery, to be painted in a variety of colors.

After placing a dark blue field onto watercolor paper, I used a bleach solution to extract color where I wanted to place light-valued trees. The influence of bleach on dye is one of the unique luxuries afforded by this painting medium.

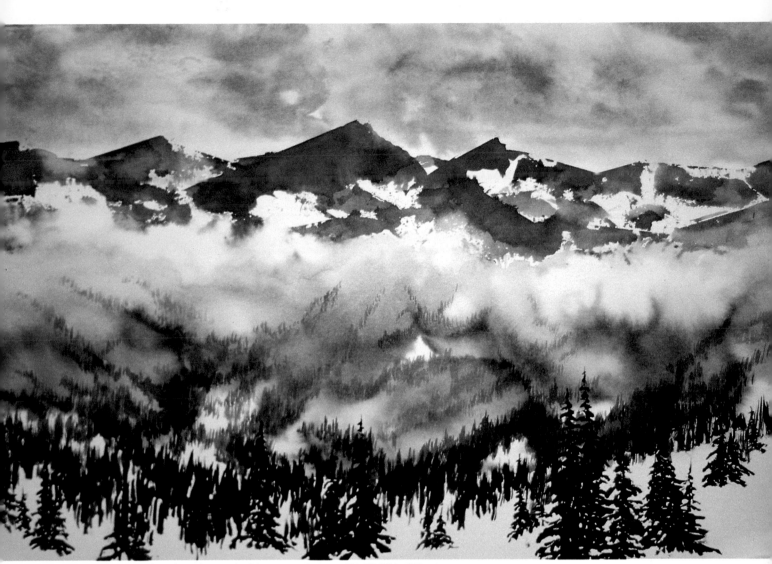

LOWERING WEATHER, dye color and watercolor ink on watercolor paper, 12″×15″ (30.4×38.1 cm).

I often refer to places of mystery in mountain landscapes, where several landscape elements merge and become individually indistinguishable. Mountain peaks rising into cloud banks or cloud formations settling in a meadow area are such occurrences. They heighten the emotional statement of a scene.

I created the cloud effect by applying a weak solution of bleach while the painting was still damp. By placing moistened colored pieces of rice paper onto dry watercolor paper, I was able to form the image of a mountain range. I painted in the foreground trees with watercolor ink.

TRANSFERRING COLOR TO DIFFERENT SURFACES

Just as a printmaker will make a number of prints using different amounts of ink to determine the correct value for the print, so the painter with dyes can produce a number of copies of a painting, each possessing a different quality of color. This is done by simply placing several sheets of rice paper or some other porous papers on top of one another. When the dye is applied to the first sheet and water is added, certain amounts of dye color will flow through the top sheet onto subsequent sheets, depending on the intensity of the original color and on the quantity of moisture placed on the top piece. Color can also be transferred from one piece of rice paper to another after the color on a single sheet has dried. For this reason, I have collected a large box of colored rice paper scraps that I keep close at hand in case I need a certain type of color for a painting in progress. The scrap of dried paper is placed over the desired area, and water is applied either by brush or by spray bottle, depending on the effect sought. Sometimes the paper is moistened prior to the reception of the color paper scrap. When the dye color has been transferred to the painting, it must be dried instantly to avoid forming a hard edge of color. Certain effects can be achieved only by transferring color from one piece of paper to another rather than applying color directly from a marker.

Not only is there a multiplicity of techniques to use in solving any given problem, but there are many different paper surfaces that produce unique expressions. Often I use a variety of porous papers besides rice paper. Those that work best for me are white paper towels, high-quality paper table napkins, facial tissue, and white desk blotters. Each of these papers has its own physical strength, and each will produce its own unique color image.

Obviously, you have to take great care when working with vulnerable papers such as napkins and facial tissues. Too much water will turn the paper into pulp. When painting on these surfaces, I bleed the color through a rice paper sheet, since it is difficult to place color directly from dye markers on these thin papers without tearing them. This method also reduces the chances of dissolving the fibers of the fragile material.

As a result of using such porous papers, the paintings are very impressionistic in style. It is difficult to produce clear descriptive images since even the dye marks made directly from the dye markers have sufficient moisture in them to cause the color to spread on thin papers.

When water is applied to sensitive tissues, foreground, middle ground, and distance tend to be intimately related because of the spontaneous spread of the color. You feel fortunate if the color image suggests a certain landscape environment following such erratic expansion and blending of colors. When you have achieved a successful painting and carefully dried it, you can gently stretch it and tape it to a

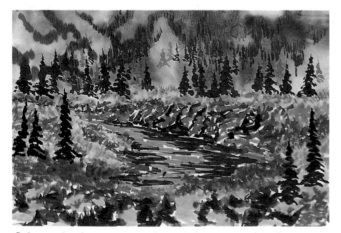

I drew a landscape onto a sheet of rice paper using dye markers, then placed it on top of several sheets of rice paper.

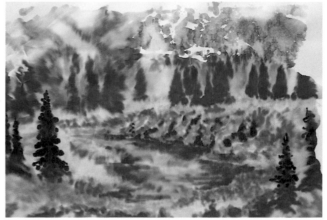

The color washed through the top sheet of rice paper to the rice paper below. I immediately separated the sheets of rice paper and dried the paintings with a hair dryer. You may or may not add details to the painting, depending upon the desired effect.

pure white mat board. Since stretching lightens the color values slightly, the painting will be altered.

This kind of painting has to be matted and framed carefully. Its surface must not come into contact with the glass in the frame, and no moisture of any kind must touch its color. The high humidity in a building can destroy the painting if the picture is not securely housed in its frame. Though it sounds as if painting on such vulnerable material leads to perishable and difficult-to-control results, nothing could be further from the truth. These paintings have a mystique about them that cannot be duplicated in any other way or on any other surface. Sometimes, what is most difficult and demanding can deliver a most amazing and satisfying image.

Interesting effects can also be produced by bleeding dye color through rice paper onto smooth, hard surfaces, such as core board and bristol board. You can't place color directly from a dye marker onto these surfaces because there will be no blending or bleeding of colors when water is added. If color from the rice paper is deposited onto a dry, hard surface, there is little or no movement of the color. If the hard surface of a board is moistened prior to receiving color from the rice paper, the water will carry the color across the board until the water is finally absorbed into its body. The value of the color is much lighter and the intensity is decreased when the dye marker colors are bled onto slick, hard surfaces.

Once dry, the color becomes permanent and cannot be altered by adding more water. This can be an advantage to the painter, since additional color can be added anywhere on the board without the risk of changing the previous images formed at the time of the first application of color. Because the colors are lighter on hard-surfaced material, you often need second and third coats to attain a desired value or intensity.

Dye color landscapes painted on smooth, hard surfaces can produce the feeling of great sensitivity because the color is light and delicate. These types of surfaces lend themselves to spatial expressions where the subject matter is meant to be middle or distant images rather than detailed foreground images. Transparent watercolor inks on smooth surfaces create a more intense expression since the color is painted directly on the board as opposed to dye color, which loses some of its intensity when bled through rice paper.

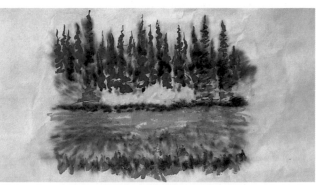

Using dye markers, I drew a landscape onto a piece of rice paper. Then I placed the drawing on top of several layers of a quality white paper napkin. Color washed through the rice paper drawing onto the napkin. As the color bled through the several layers of paper, it dissipated, producing a less vivid scene.

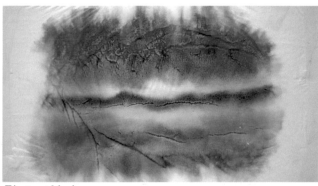

First napkin image.

Second napkin image.

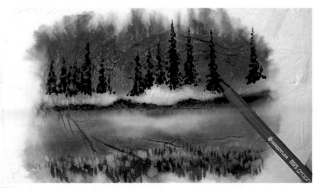

With dye markers, I added details to a dry napkin painting.

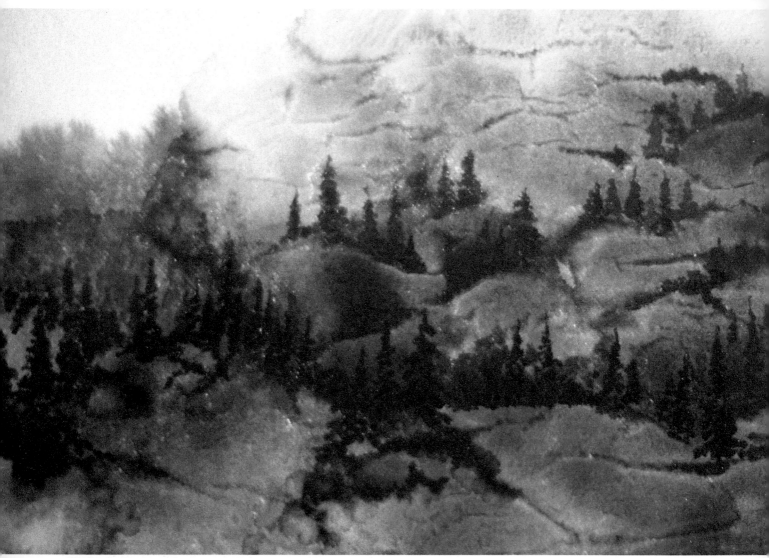

VAPOROUS MORN, dye color on facial tissue, 8″×12″ (20.3×30.4 cm).

To achieve this impressionistic image, I bled color through a sheet of Japanese rice paper onto a sheet of facial tissue. Blue, green, yellow, and gray marks were placed on the rice paper, then water was sprayed onto the surface. When the color began to blend and spread, I placed the rice paper on top of the facial tissue. The color rapidly shifted to the tissue and spread even more rapidly owing to the extremely porous surface. When the color covered most of the paper's surface, I dried it with the hair dryer, then carefully stretched and taped the painting onto a piece of white mat board. I used a small black marker to draw the groves of pines. This image has an atmospheric quality reminiscent of many Oriental paintings.

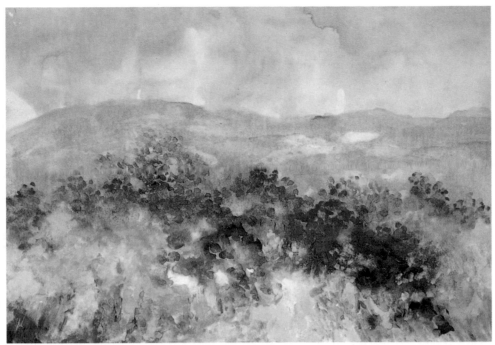

I did this rather delicate painting on core board. The hard, slick surface lightened the dye colors. The softened hues and lighter values created a sense of serenity. Transferred dye colors blended in the sky area and distant hills. The foreground foliage was formed with watercolor inks.

The method I used to make this dye and watercolor ink painting on core board was to transfer the dye color to the distant and middle-distant areas and use watercolor ink on the foreground details.

DELICATE DAY, dye color and watercolor ink on core board, 10″×12″ (25.4×30.4 cm).

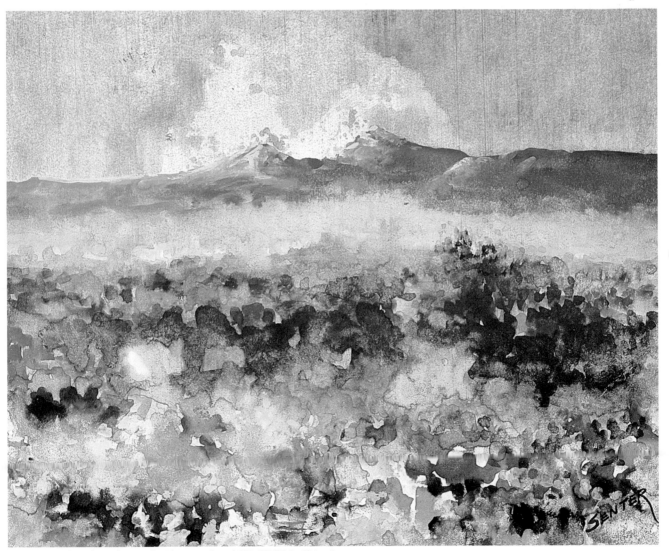

TWIN PEAKS, dye color and watercolor ink on core board, 10″×12″ (25.4×30.4 cm).

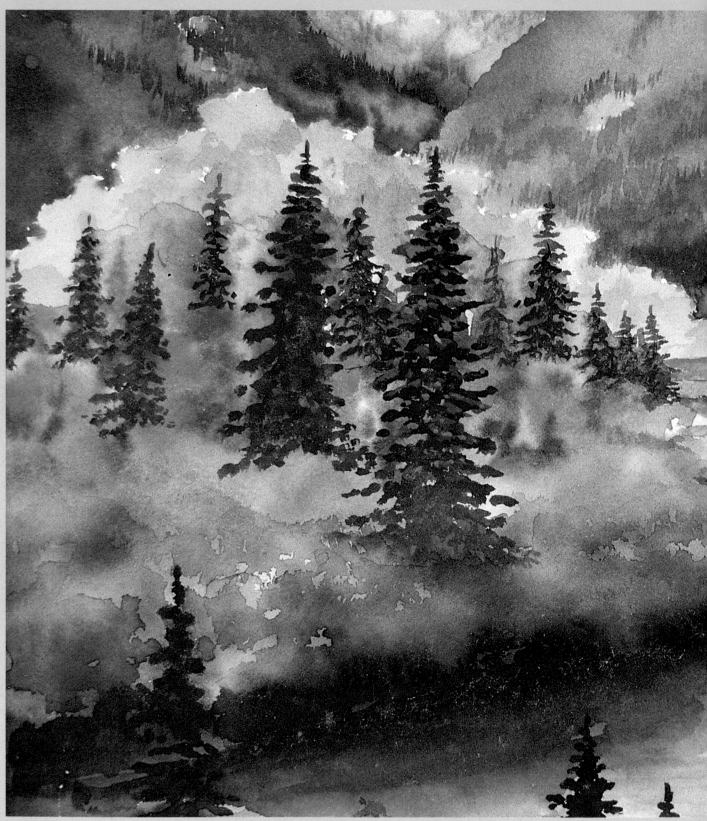

COLOR ALTERATIONS, dye color and watercolor paint on watercolor paper, 8″×10″ (20.3×25.4 cm).

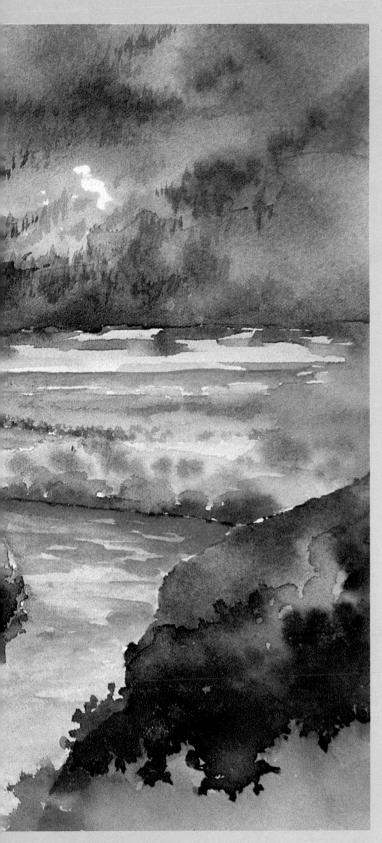

Part III

COMPOSING LANDSCAPES

CONVEYING THE VISUAL IMPACT OF SKIES

Though each natural element—sky, landmass, rock, water, light—is diverse in shape, color, and texture, I try to place them in such a way that their extreme differences blend in a continuity of expression, with one element affecting another in a complementary way. I always strive for the sense of landscape as image—a congenial whole. The beauty of an entire area is composed of many diverse landscape elements, such as trees, hills, grass, water, and clouds, each in its own unique lighting.

On occasion, I emphasize and contrast certain elements, such as a rocky pinnacle or a grove of yellow aspens in a painting, but I do not do it at the expense of all the other elements in the picture. I make sure that the element I emphasize has its counterbalance elsewhere in the painting. In creating a unified landscape, I make sure that the extreme color differences and diverse forms in nature somehow complement and support one another's unique forms.

My goal is to emphasize certain elements in my subject matter without overwhelming the rest of the composition. These elements of nature are the tools artists use to create a myriad of moods and emotional statements. As a mountain backpacker, I use these many elements in paintings that express my personal relationship with the heart of the mountain.

In landscape painting, the role of the sky varies from being the actual subject matter of the work to being of subordinate interest. Most of my paintings contain dramatic skies in which conflicts and contrasts of mood, color, and value exist. I believe that skies are dramas in which opposing emotional environments interact in an ever-changing scene. The play of dark against light in a sky suggests a vast array of human emotional experiences from despair to hope, from depression to joy, and from ignorance to faith and light.

The quality of the sky determines the complexities or simplicities of the rest of the picture. The sky must contain a good variety of colors, shapes, values, and movement. Not only does it lie in a physical place on the picture plane, to which the viewer is automatically drawn, but the sky sets the stage for the development of the painting. A weak bleach solution is most often used in changing colors and values of skies once they have been bled through rice paper to watercolor paper. Often it is reflected in nature—in bodies of water (whether they be of ocean size or rain-puddle size), on light-valued rock walls, and on other reflective surfaces.

The sky is perhaps the only area in a painting in which almost any color will be accepted as reality. While walking through mountainous regions for many years, I have witnessed in skies every conceivable color and composition, from the great vault-like tumultuous thunderheads with their ominous colors and values, to the serene cerulean blues of a calm summer day. Each expression bears its own emotional and visual impact on the viewer.

A successful watercolor sky should have the marks of spontaneity and fluidity in it. No bigger mistake can be made when developing the sky area than to overwork or repair part of it. The sky must be one continuous flow of transparent color, or it will look belabored. An artist has to develop an intuitive touch for painting the sky so that it keeps its look of authenticity.

In this painting, the sky is the focal point. Its dramatic swirling shapes and ominous, somber colors contrast with the brilliant white of the foreground snow. What little ground cover there is does not compete with the powerful influences of the sky. For me, this rather simple, uncomplicated work makes a profound statement. To produce the foreboding look of the sky, I placed brown and black dye color randomly across the surface of a sheet of rice paper and let it bleed through to the premoistened watercolor paper.

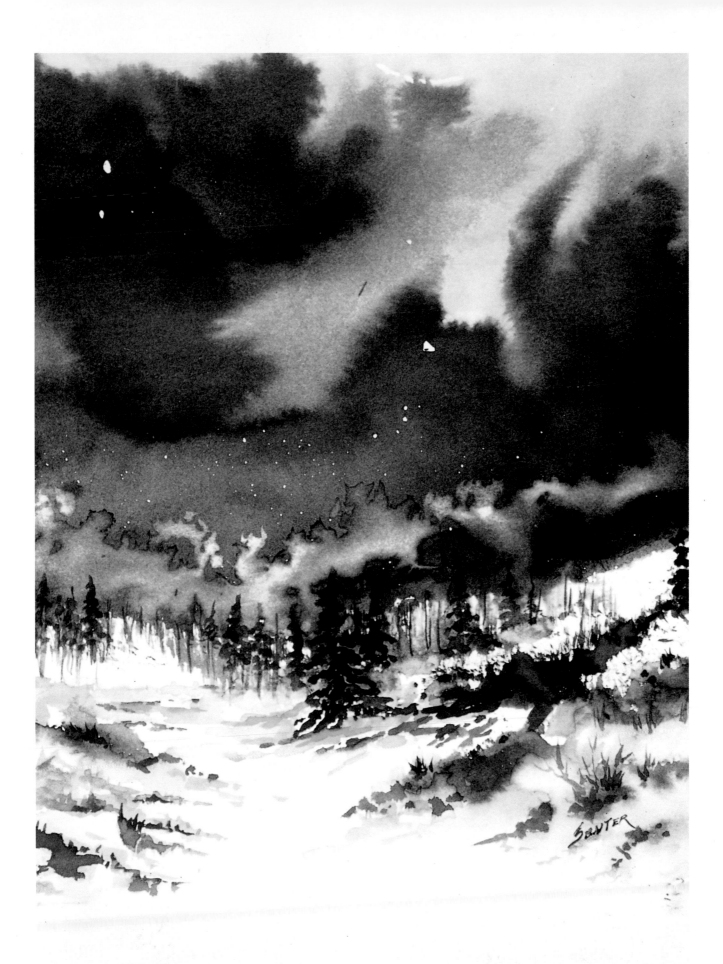

THE CALM BEFORE THE STORM, dye color on watercolor paper, 12″×18″ (30.4×45.7 cm).

The painting of a sky normally involves three separate steps. The first is the selection of the desired colors and their application to a sheet of rice paper by the chosen dye markers.

The second step is to moisten the portion of the watercolor paper selected for the sky area and bleed the color from the rice paper through to the watercolor paper by pulling a wide water-soaked brush across the surface of the rice paper.

The third step has to be done while the color is still moist. A weak solution of bleach and water is placed in areas of the sky where clouds are desired or where the value of the sky is to be lighter. Timing is very important in this step if the sky is to have a variety of color and appear to be dimensional and filmy.

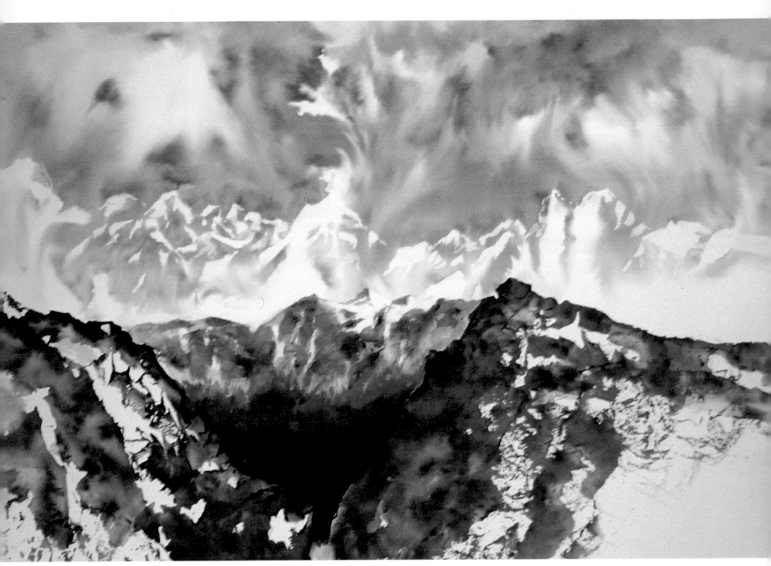

HIGH ALTITUDE TURBULENCE, dye color on watercolor paper, 24" × 28" (60.9 × 71.1 cm).

In this painting, the sky, windswept and tumultuous, intermingles with the snow at the mountain's summit. The colors of the sky are reflected also in the distant peaks and the brilliant snow fields, unifying the mountain range with the sky. To prevent the sky from overpowering the composition, I placed a rugged, hard-edged range of mountains more frontally in the picture. Some of the sky colors are echoed in the foreground of the landscape, giving a sense of cohesion to the painting. These combinations of color and texture emphasize the rugged terrain and bitter cold of the wind-tossed high altitudes.

Skies: Depicting Light's Variations

Artists often modify light to create a mood that best expresses the emotional relationship they experience with certain environments. Atmosphere and light change the normal color of landscape elements as they filter out the color received by our eyes. The range of light rays extends from cool to warm.

I usually begin a picture by painting in the sky area first. The kind of light emerging from the sky affects every form in the landscape. The color, value, volume, and intensity of each element is directly related to the light of any given sky. What determines the quality of light and the kinds of color in a sky are the time of day, angle of the sun, particulate matter in the air, humidity, and reflections.

A successful landscape composition relies on a variety of forms and colors, as well as a variety of light qualities, to lead our gaze from a sun-bathed spot to a shadowy area and on to a place of backlighting. Were we forced to choose between color and light as the only element allowed in making paintings, we would have to choose light since it is the quality and variation of this element that contributes the most to the authenticity of the real world. Color is important but not as important as light.

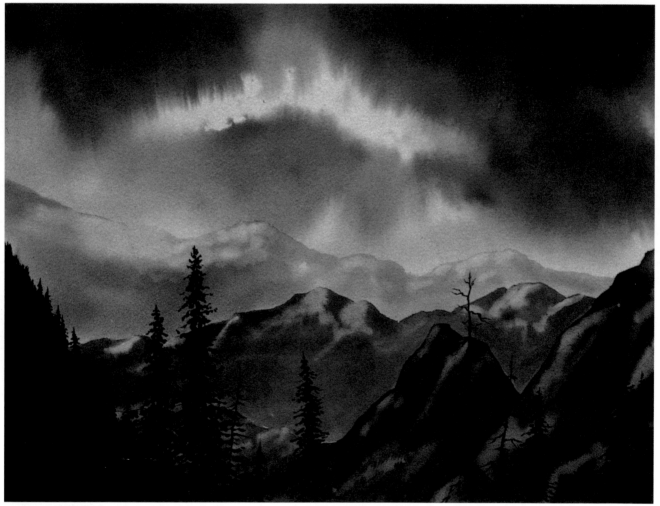

MOUNTAIN OBSCURITIES, dye color and watercolor ink on watercolor paper, 14″ × 18″ (35.5 × 45.7 cm).

The emphasis in this painting is on the dark, somber mood of the landscape. I have often seen the sky and surrounding mountain landscape suddenly transformed into a murky light that would cause great concern for one's physical safety. The very nature of mountainous elements—rocks, steep inclines, and deep canyons—lend themselves to creating contrasts in lighting by extreme changes of value in the sky. Lightning is prevalent in high mountains; its flashing light and thundering bellows echoing off rock walls and roaring through deep canyons are awesome to experience. To create the ominous sky, I used dye colors. For the land, I worked with transparent watercolor inks. In both areas of the sky and mountain peaks, I used bleach to lighten the value of the color and give the sense of distance.

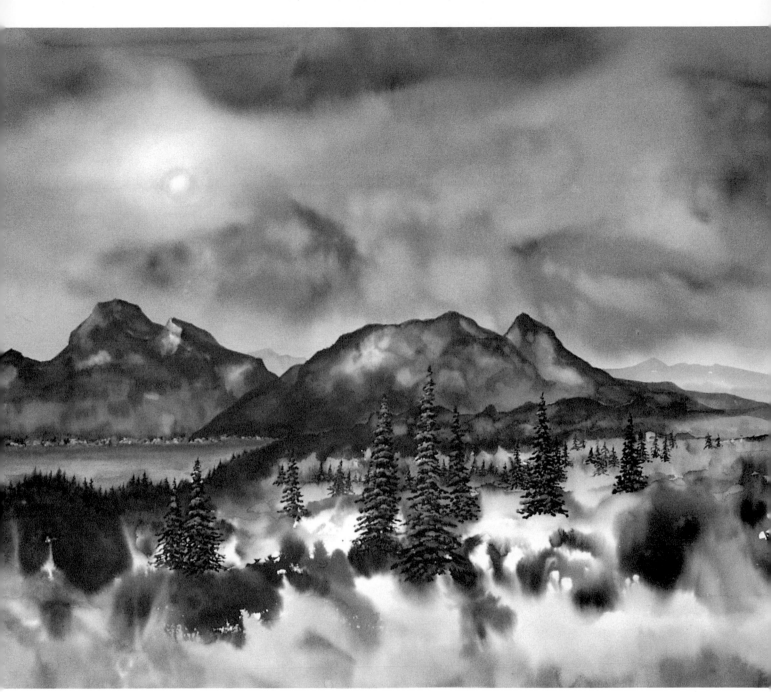

BREAKTHROUGH, dye color on watercolor paper, 12" × 14" (30.4 × 35.5 cm).

Following the height of a storm, I was impressed with the way the infused light of the sun broke through the clouds, casting an eerie haze of color and light across the entire landscape. The rather harsh outlines of the two dark mountainous out-croppings contrasted with the delicate rays emanating from the emerging sun. At the far right, the small, distant range of mountains relieved the intensity of the rest of the painting, cre-ating an interesting spatial contrast to the middle-ground rock formations and foreground trees. The sun and its struggle to

disperse the storm's clouds is the focal point of this painting. Before transferring the dye colors from the rice paper to the watercolor sheet, I used Maskoid to preserve the white area of the watercolor paper that would become the sun's image. When the color bled through to the watercolor paper, I placed a weak solution of bleach and water on the color around the sun to create an effective dispersion of light. I picked up the sky color in the loosely interpreted foreground to hold the landscape to-gether visually.

Skies: Establishing a Sense of Space

Light cannot be spoken of without discussing space. Clouds produce the quality of light in a landscape, and light creates spatial deviations. Space is the most instrumental factor to consider in developing a successful landscape painting. The other elements that make up the totality of an environment have significance only in terms of the space they occupy.

Distances between objects, distances between the viewer and the various places in the landscape, the most distant place in the composition, the suggested spaces created by the vagueness of the objects in the painting—mist, clouds, and shadows—all give the painting its mystery and its meaning. These spatial variations affect the emotions and can evoke a sense of inspiration in us.

A number of factors help determine any given object's position in space. Generally speaking, objects that are larger, darker, warmer, more intense in color, and lower on the picture plane are seen as frontal or in the foreground. Objects that are lighter

in value, less textured, cooler in hue, not as distinct in outline, and higher on the picture plane seem to recede or appear to be in the background. Objects with qualities somewhere between these two extremes lie in the area we call the middle ground.

Besides these three clear spatial positions in a painting, there are numerous subtle spaces that landscape elements occupy, and their clarity or vagueness must be dealt with accordingly. The range of clarity or ambiguity of space in a painting can be great. It plays a big role in expressing the intent of the artist when portraying a certain emotional experience he or she has had while viewing a certain part of nature. Some paintings contain both the sense of the vista in space and the intimacy of space by the way objects are painted and positioned in the composition. The manipulation of space by the artist has always been one of the most valued luxuries in the field of painting. It does not always come easy, but when it is mastered, it is very rewarding.

The large thunderheads at the top of the picture plane and the long light rays that extend to the lower portion of the painting monumentalize the sky while minimizing the land. These great contrasts in the picture make the composition seem simplistic, but the overall visual impact is complex and lends itself to an imaginative interpretation. To create the paradoxical effects of a sky frontal in space and hills at a great distance, I washed the sky onto the watercolor paper through the rice paper, then used a bleach solution to form the white clouds and their long vertical rays. I painted the land and its vegetation with watercolor inks.

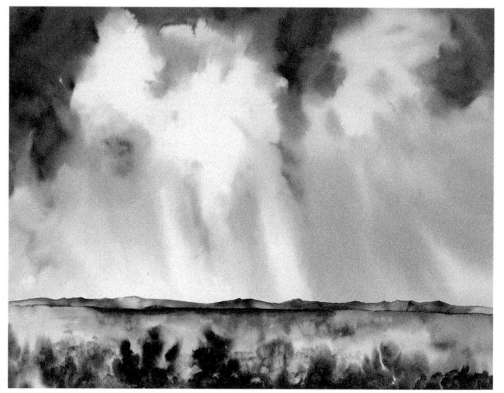

HIGH SKY, dye color and watercolor ink on watercolor paper, 16″ × 20″ (40.6 × 50.8 cm).

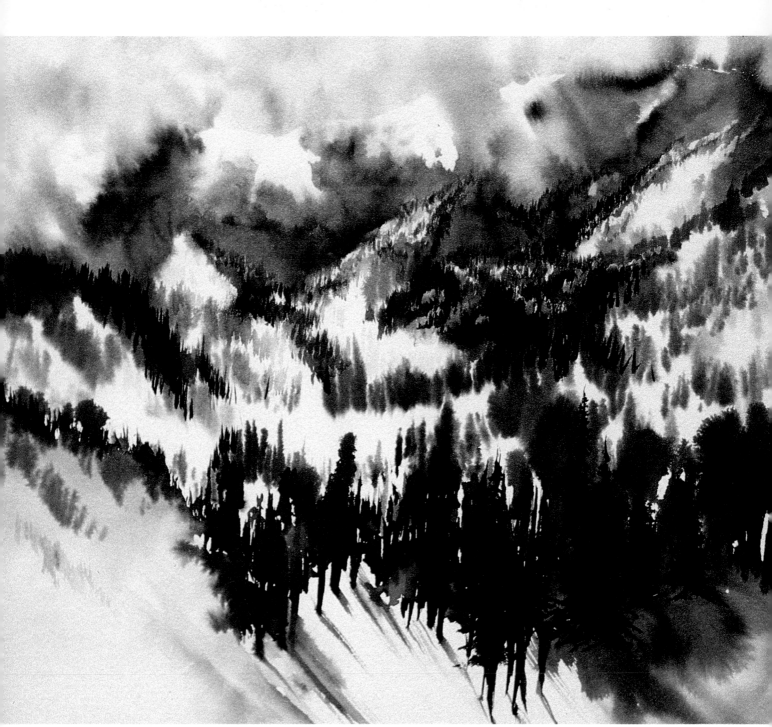

SUMMIT OBSCURITY, dye color on watercolor paper, 12"×14" (30.4×35.5 cm).

When confronted with the grandeur and sheer ruggedness of mountains such as these, one experiences a sense of reverence. To present to the viewer the obscure zone of clouds and mist, where rock and sky converge, I used a wet-into-wet technique with small amounts of bleach. The sense of distance was enhanced by the size of the pine trees in the foreground. With this painting, I wanted to allow the viewer to exercise his own imagination, to feel something emotionally and visually.

RENDERING MOUNTAINOUS TERRAIN

My interest in painting had its origin in a desire to permanently record my emotional and spiritual reactions to nature, particularly to the mountainous terrain. I have been enchanted not only by the mountain's physical beauty but by its changing moods; sweet odors; cool, clean air; tranquillity of pristine lakes; sounds of elk or moose crashing through timber; the flash of a rainbow trout rising for a fly. Some of its attractiveness for me is its deceptively rugged wilderness areas—its soil, rock, vegetation, water, light and shadow, color, texture, and weather.

There is no easy access to the more remote areas of the mountains. To reach an alpine lake near timberline, a degree of difficulty must be overcome, and the physical price paid makes the effort more meaningful and the reward more pleasurable. To communicate the relationship between the visual sights and the emotional experiences of the mountain is what my work is about. I concur with the famous critic John Ruskin, who said that "a mountain painting is always worth three times one of any other subject."

There are a great variety of shapes, textures, and colors that make up individual mountains and entire mountain ranges. Each of these elements must be clearly exhibited when rendering them in dye color and ink. Soft dye colors lightened with a weak solution of bleach are used in displaying distant images, while dark color is bled through rice paper to the dry surface of watercolor paper in depicting rugged individual peaks in the foreground. Crumpled color-saturated rice paper can be daubed onto dry watercolor paper to create the sense of rock piles and other textural debris found on mountain slopes.

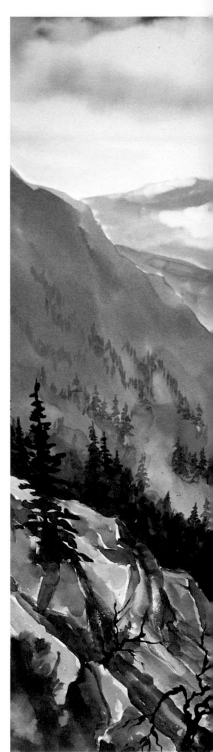

This rather panoramic view of a mountain range includes distant peaks, middle-ground rock structures, a glacial lake, near-distant trees, and foreground rocks. This scene, high in the mountains of the north fork of the Wind River in northern Wyoming, is typical of many high lake environments. The lake was reached only after a steep ten-mile walk over boulder fields and through dense areas of fallen timber. I wanted to create the sense of being in the midst of this environment by bringing the viewer close to the foreground rocks and yet allowing him to gaze into the far distance at the snow-capped peaks. This particular spatial place in the painting was approximately two miles from the lakes. Since it was late in the afternoon, the shadows were already obscuring some of the details in the pine groves and the sides of a rock outcropping on the right side of the painting. I used the rice paper transfer method for the sky. The rest of the painting was completed with watercolor inks applied directly to the watercolor paper by brush. Lightening effects were created with a bleach solution.

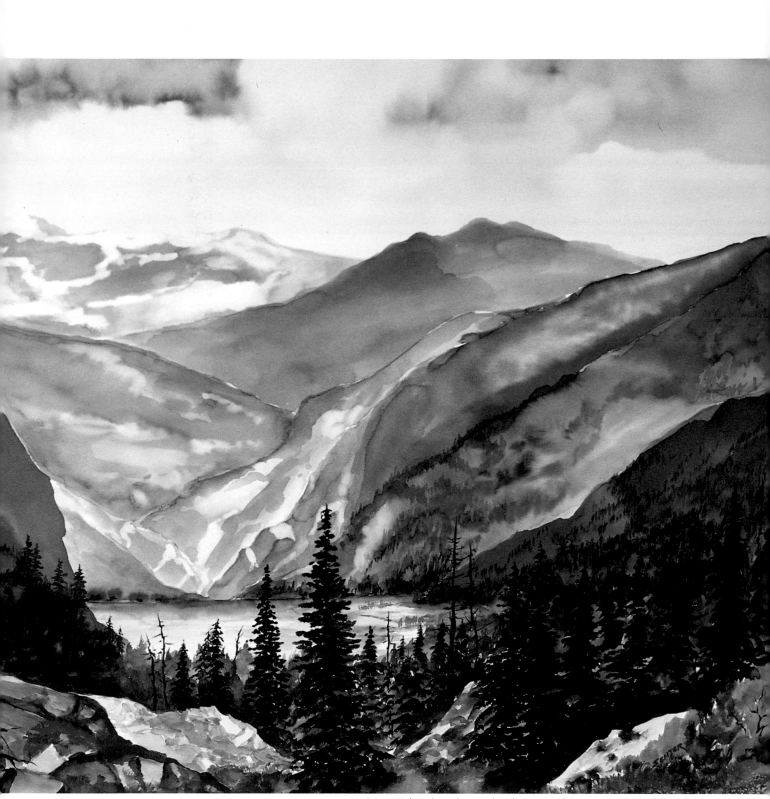

TWIN LAKES, dye color and watercolor ink on watercolor paper, 14"×18" (35.5×45.7 cm).

Mountains: Rugged Slopes and Rock Structures

Mountains are made up of rock structures. Rock structures seem to hold everything together from the smallest piece of sand in a meadow stream to the highest majestic spire on the mountain's peak. Sometimes they seem to have a polished gentleness, sometimes a physically dangerous appearance. Some stand as great immobile sentinels to the mountains; others are in constant motion along streambeds.

Rocks are very functional in nature. Glacial lakes are enclosed in rock and ice; sand in streams acts as a water-purifying agent; rock caves are homes to many animals great and small; and great rock basins collect winter's snows to form great snowfields that turn into small streams that feed larger streams and lakes. Ultimately, rocks give to the landscape a sense of strength and permanency.

My aim here was to show the vast expanse of a great mountain with all its rising and falling undulations. From a distance, a mountain environment takes on a very different appearance than it has at close range. The slopes seem to fall away from the summit in a rhythmic flow of lines created by the sharp ridges and the groves of aspen and pine. In Snow Bound *I emphasized the linear qualities of the composition by contrasting the lines established by the tops of ridges, shadows, and tree lines with the whiteness of the snow. The dark sky is a backdrop for the mountain and acts as a color influence on the rest of the painting. To emphasize the height of the mountain and allow for the development of outcroppings and depressions, I made the picture vertical. I used jagged pieces of colored rice paper, moistened and laid down, or sometimes pressed down, onto a sheet of hot-press dry watercolor paper. If some of the dye color appeared too harsh texturally or too dark, I used a wet watercolor brush to soften and lighten the area and create the effect of shadows cast by rocks and trees. Watercolor inks were used to paint a number of individual trees near the bottom of the picture plane.*

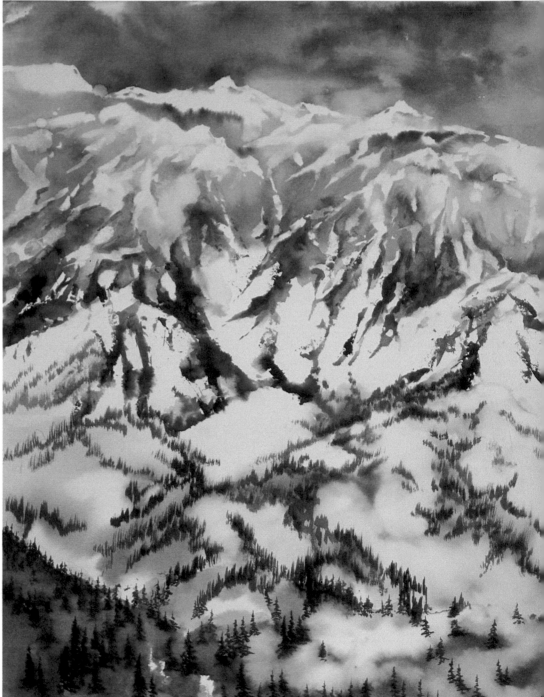

SNOW BOUND, dye color and watercolor ink on watercolor paper, 18″ × 22″ (45.7 × 55.8 cm).

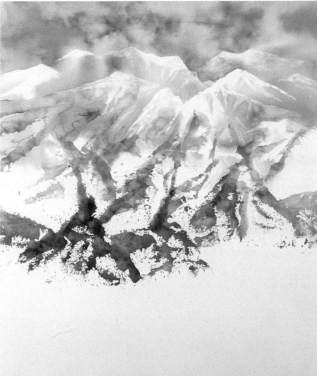

In most of my landscape paintings, I begin with the sky. Here I placed black and blue dye on top of each other randomly across the surface of a sheet of rice paper. By allowing some of the rice paper to remain untouched, I made sure that I would have a variety of values in the finished sky when I bled the dyes through the watercolor paper. Timing is of great importance in this first step because of the limited drying time of the dye colors. Just prior to the introduction of the moistened rice paper sheet, I saturated the designated area for sky on the watercolor paper. The damp rice paper was laid down and lifted several times on the watercolor sheet because the sky area was larger than the size of the rice paper. The potency of the dye color on one piece of rice paper is normally sufficient to cover a large sheet of watercolor paper. This process extracts the biggest percentage of color from the colored rice paper sheet. After the dye color was transferred to the watercolor paper, and while the surface was still wet, I quickly applied a light wash of one part bleach with four parts water to produce a more brilliant blue that will have a penetrable visual effect owing to the soft transparent cloud formations created by this method of color change.

When the sky area was completely dry, I used a No. 2 watercolor brush dipped into a stronger bleach solution, approximately one part bleach and one part water, to extract areas of color that would help form distant snow-covered mountain peaks. Choose a synthetic watercolor brush when using bleach because sable and other natural-hair brushes will be burned quickly by the solution. To give the sense of middle ground to the painting, I tore several 2" × 2" pieces from the original sheet of rice paper used in creating the sky. The tearing of the paper produces irregular jagged edges that will produce the edges of rough rock ledges and stands of distant pines. I moistened one of the scraps of precolored rice paper so that it would give up its remaining color when daubed onto a section of the partly dry and partly wet painting. I continued this approach to the application of color until the mountain and tree formations moved forward on the picture plane to a place that demanded a more realistic, detailed rendering of surrounding configurations.

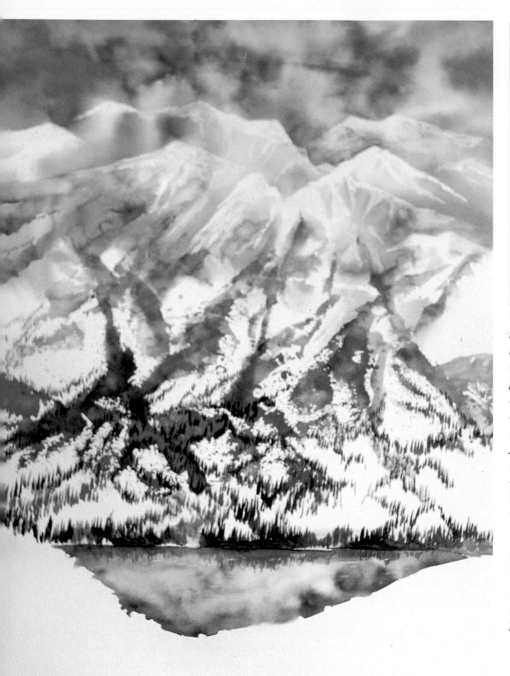

To suggest the density of trees, I moistened a section of the watercolor paper and painted directly into the wet area with a mixture of sap green and Payne's gray transparent watercolor inks. The diffusion of color gives the impression of a heavily forested area at yet some distance from the viewer. To develop the foreground, I moistened the lower section of the painting and repeated the process used in painting the sky to suggest its reflection in the lake. Just prior to the drying of the water area, I painted in the reflection of the trees near the shoreline with a mixture of Vandyke brown, juniper green, and Norway blue watercolor inks, using a No. 8 Winsor & Newton red sable brush. The swatches shown here illustrate my color palette for this painting.

When the painting was thoroughly dry, I painted the foreground landmass and added a stand of pine trees in some detail using chrome yellow, moss green, and sepia watercolor inks.

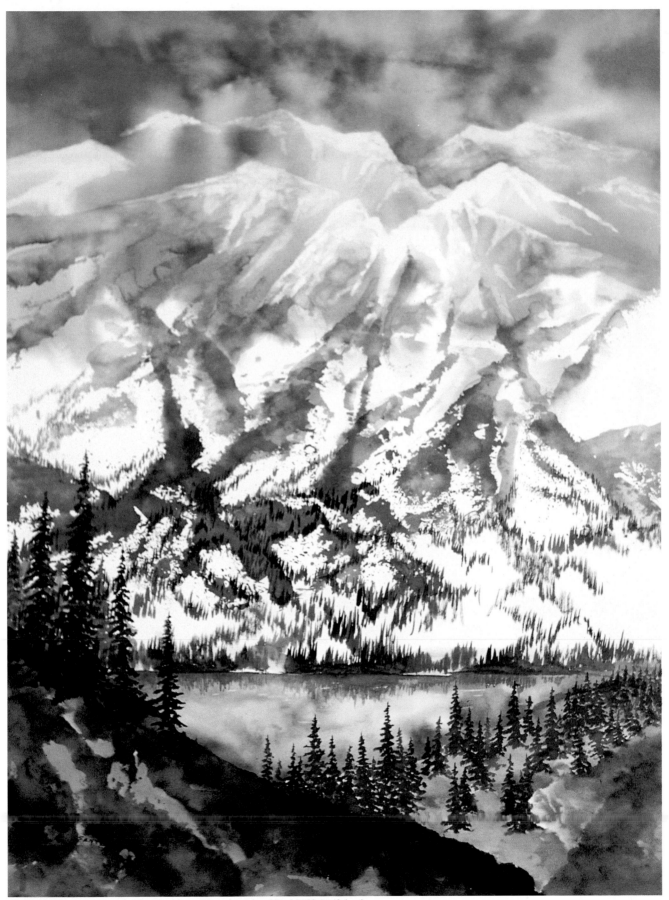

ALPINE LAKE, dye color and watercolor ink on watercolor paper, 12″×16″ (30.4×40.6 cm).

Mountains: Creating Contrasts

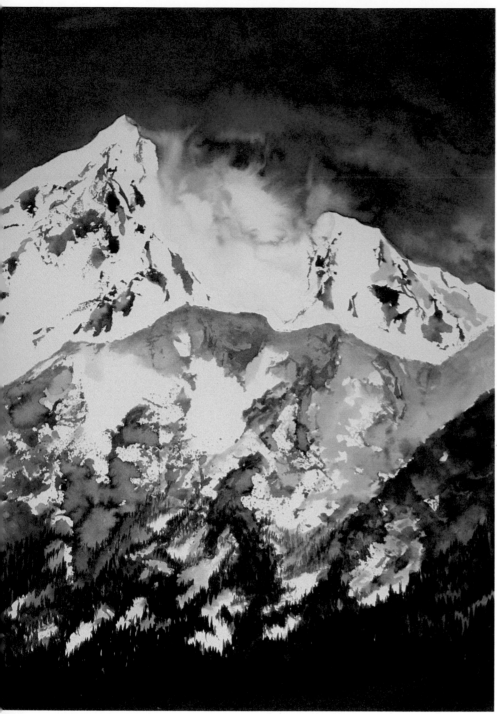

PRINCETON PEAK, dye color on watercolor paper, 20" × 26" (50.8 × 66.0 cm).

In this painting, the threatening sky has not yet enveloped the brilliant snow-covered edifice, which produces a clash of emotional experiences. The tension between the darkened sky and the white mountain stays in balance, with neither dominating the other yet with power emanating from both. To create this contrast, I used dark blues and black dye markers bled through Japanese rice paper onto watercolor paper. I moistened small scraps of colored rice paper and daubed them onto the dry surface of the watercolor paper to bring out the ruggedness of the mountain pinnacle. I applied a small amount of bleach to a portion of the peak to suggest the turbulence of windswept snow.

I wanted to show the transitional period of time that comes to every mountain in late summer and early fall. Some glacial lakes do not give up their ice covering until July, and some parts of great snow basins remain the year round. Not only is nature slow in rolling back the consequences of winter, but it is rather anxious to begin the process anew, sometimes as early as the last few days of August. The experienced hiker is aware of the possibility of a radical change in weather in a very short period of time late in the summer. A sudden snowstorm can eradicate visual landmarks and make it difficult to descend the treacherous slopes. This painting depicts the contrasts between land with snow cover and land with ground cover and the beautiful transitional zone between the two. The lake in the foreground reflects both the area of snow and the mountain's exposed vegetation. To paint the sky and lake, I used the dye transfer method. For the middle-ground mountain area and the foreground trees I worked with transparent watercolor inks.

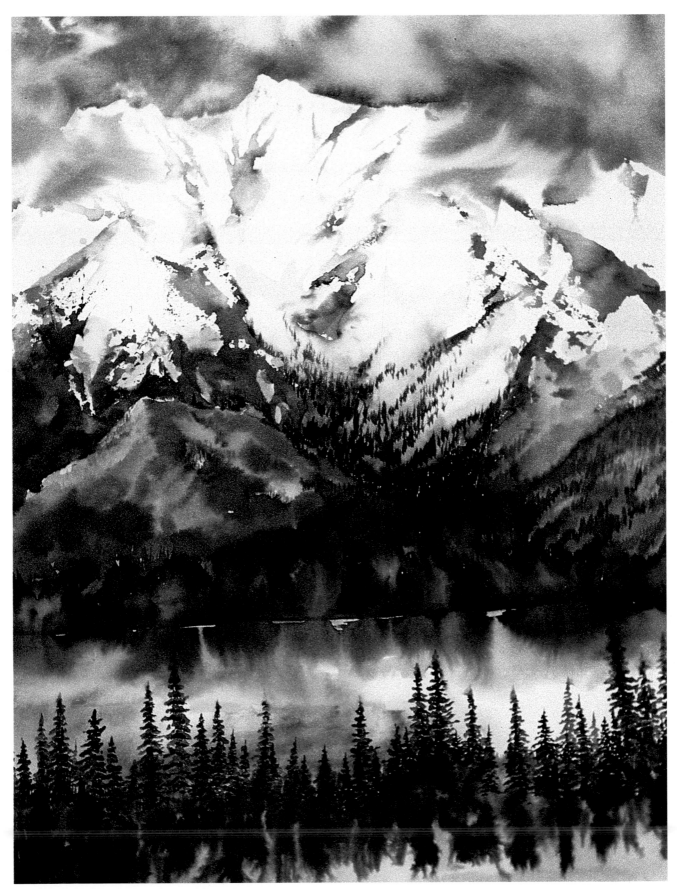

FIRST SNOW, dye color and watercolor ink on watercolor paper, 14″×18″ (35.5×45.7 cm).

CAPTURING THE TEXTURES OF ROCKS

From the tiny, smooth pebble found buried in a mountain stream to the massive free-standing pinnacle rising into the clouds, the giant stones strewn across great boulder fields, and the sheer wall of rock rising vertically from a canyon floor, rock surfaces of all kinds and sizes exist in great variety in the mountainous landscape. They provide a kaleidoscope of color with their many-faceted surfaces. Their color continually changes with the amount and quality of light reflected from them at various times of the day in various kinds of weather. They provide an array of sculptural images that vary from realistic depictions of other living forms to imaginative, surrealistic shapes that are primeval in nature.

Just as there is a multiplicity of rocks, so are there many approaches to painting rocks. A number of things must be considered before a rock or number of rocks are rendered by the painter. Not only must the type and size of rock structures be decided on, but distance from the viewer is of utmost importance. Each decision dictates both the method and colors to be used in depicting rock images and their place in the composition.

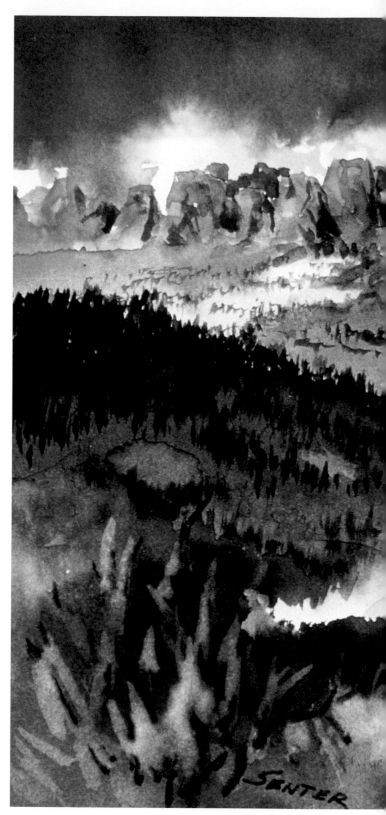

Throughout Wyoming, there are areas where large rock outcroppings pepper the landscape. These rock structures vary in color according to the time of day and the quality of light. In this painting, I show the intensity of color and light late in the afternoon, as the sun is descending behind a Western range of mountains. The last rays of light fall on the rock crags, flooding them with orange color. The dark sky and foreground act as sharp contrasts to the intense rock formations. I painted the sky and ground cover with the dye transfer method, and the rocks were painted with orange and yellow ochre watercolor inks. A bleach solution helped create the white clouds in the sky and the light areas of the shadowed land.

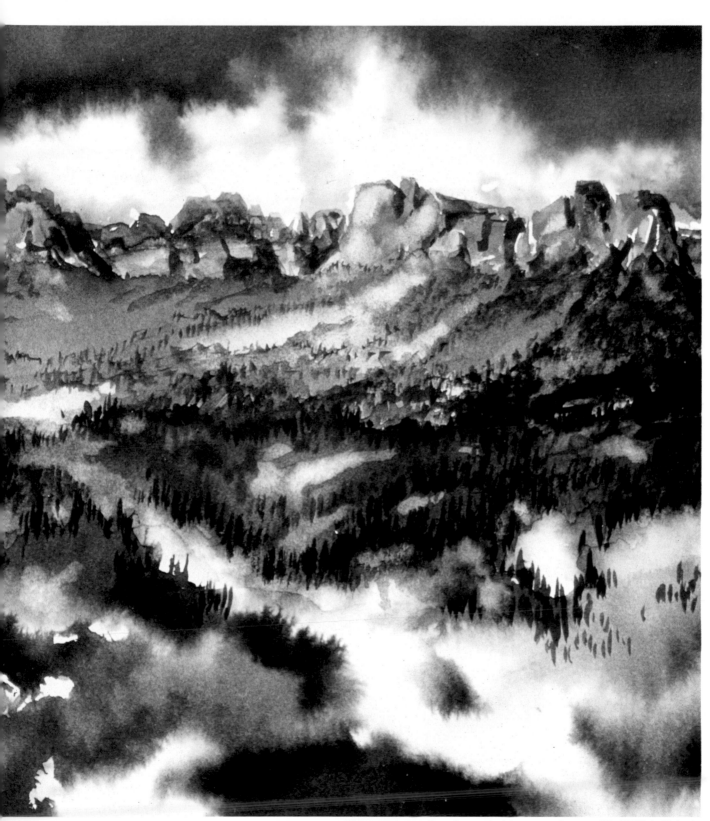

OUTCROPPING, dye color and watercolor ink on watercolor paper, 10″×12″ (25.4×30.4 cm).

Rocks: Painting a Deeply Etched Canyon

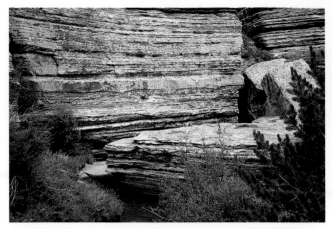

This photograph shows the unique texture of the rugged canyon walls I wanted to capture. Here I have re-created the procedure I followed.

First I sketched the major compositional shapes in pencil on my watercolor paper. Then, using dye markers, I drew brown, black, and purple lines on a sheet of rice paper.

I placed the rice paper over each major rock shape I'd sketched on the watercolor paper and applied water to blend and transfer the color to the dry painting surface.

When the dye color was dry, I drew dark lines and shadows into the painted area with a fine-point water-soluble dye marker called a Staedtler Mars Graphic 3000.

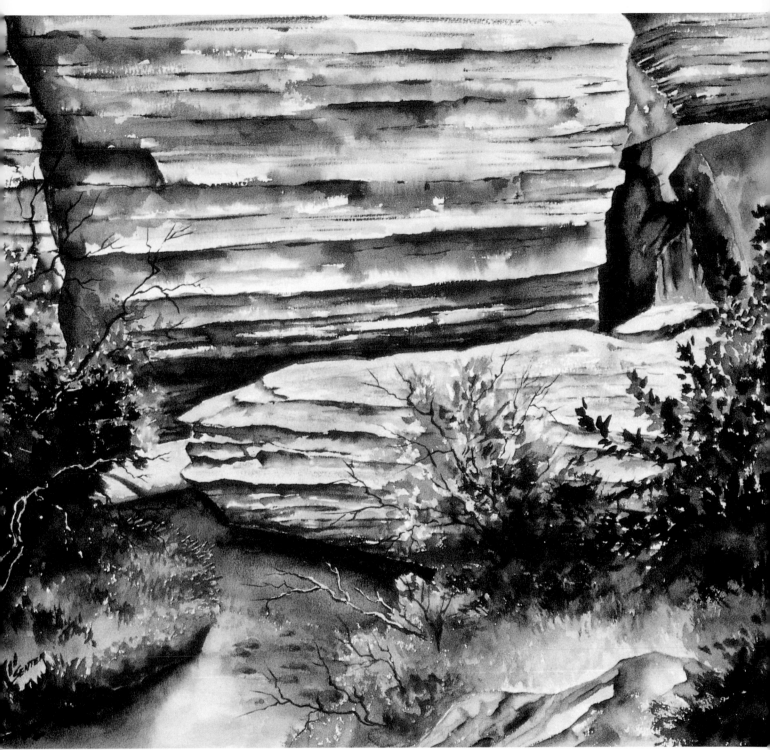

BEAVER CREEK CANYON, dye color and watercolor paint on watercolor paper, 15″ × 16″ (38.1 × 40.6 cm).

Beaver Creek near Lander, Wyoming, wends its way into a deep canyon whose walls rise to a flat prairie floor on the Continental Divide. The large boulders lying on the canyon floor trap deep pools of water in the stream. These pools contain an abundance of large German brown and rainbow trout. I have fished this stream for the past twenty-five years and have al- *ways been fascinated by the layerlike rock shelves that form the canyon's treacherous walls. In this painting I show the contrast between the rather severe rock edifices and the small, slow-moving Beaver Creek and the vegetation that lines its banks. The technique described opposite gave the rock wall its layered look. I treated each rock outcropping in the same way.*

Rocks: A Hillside View with Trees

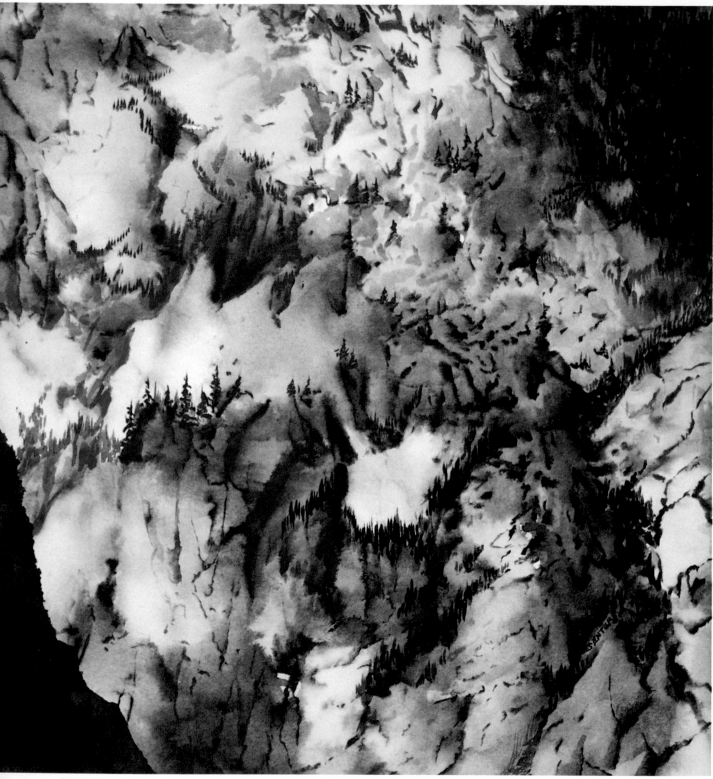

ROCKS AND TREES, dye color on watercolor paper, 12" x 14" (30.5 x 35.6 cm).

I covered a piece of rice paper with brown and black dye marker color, then crumpled the paper slightly and placed it on a sheet of dry watercolor paper. After moistening a wide brush with water, I pulled it across the crumpled paper. The color was bled through to form a rugged hillside. When the painting was dry, I added some trees with a pointed dye marker.

Rocks: A Sheer Granite Wall

Sheer walls of rock are a common sight in high wilderness areas of Wyoming. Often they surround glacial lakes at or above timberline. They are usually dramatic features of the landscape, not only because of their imposing size and power but also because of their extremes in value. Their tops are bathed in light, and their steep sides, bases, and crevices are obscured by the lack of light. The cold temperatures at this height protect deposits of snow until late summer and, in some instances, year-round. I was interested in depicting these features of power, height, and sunlight variations found on great granite walls in high altitudes. To begin this painting, I drew a simple outline of the composition on a piece of hot-press 300 lb. watercolor paper. I cut full sheets of rice paper to the drawing specifications and placed dye colors on the rice paper with a Mr. Sketch black dye marker, a gray marker, and a light brown marker. I then bled the color through the rice paper to the watercolor sheet and splashed on a weak solution of bleach to soften its intensity and value. When this first coat of dye color dried, I added more bleach to the top of the rock formation to give the sense of light falling on the canyon wall. Then, with a black Graphic 3000 flexible dye marker tip, I drew in the crevices and emphasized the shadowed areas by applying moisture to the lines with a small brush. An area to the left and bottom of the picture plane was kept white to represent a body of snow. Finally, I painted a light film of blue over the area with watercolor ink.

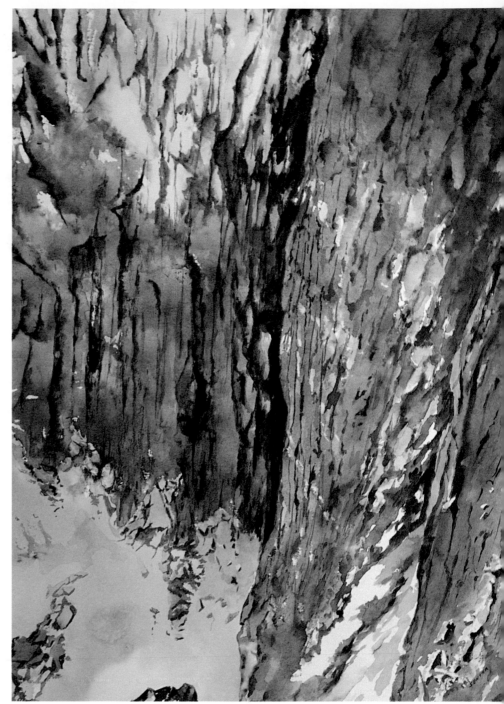

WIND RIVER CANYON, NO. 2, dye color and watercolor ink on watercolor paper, 20″ × 26″ (50.8 × 66.0 cm).

Rocks: Boulders in a Stream

Many rocks in the mountains are fragmented. Usually, you find them along riverbanks. In this scene of a dense forest and boulder-strewn stream, I painted with dye markers, ink, and watercolor paint. I used the dye transfer method for the lightest background color high on the picture plane. I painted the lower dense pine groves with watercolor inks, and the stream and large rocks with watercolor paint. A strong bleach solution lifted the light aspen tree trunks from the background color.

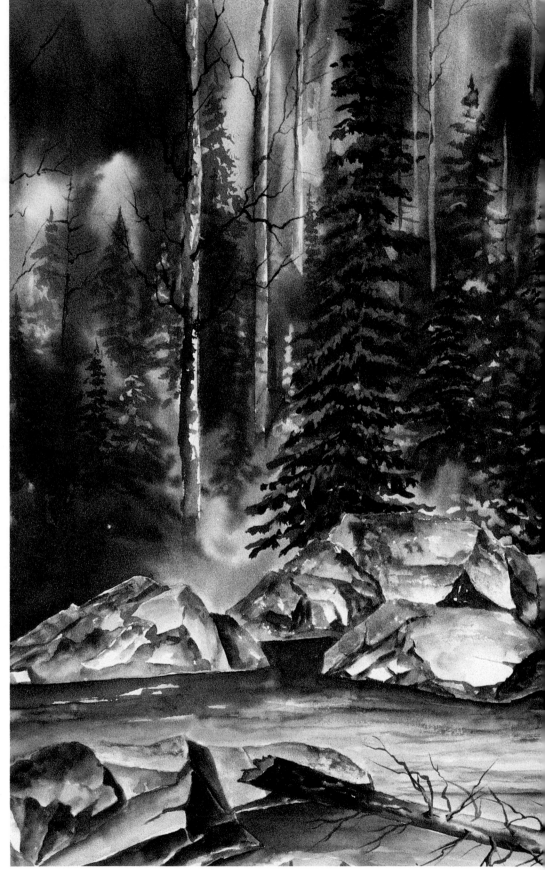

NORTH FORK OF THE WIND RIVER, dye color and watercolor ink on watercolor paper, 18″ × 22″ (45.7 × 55.8 cm).

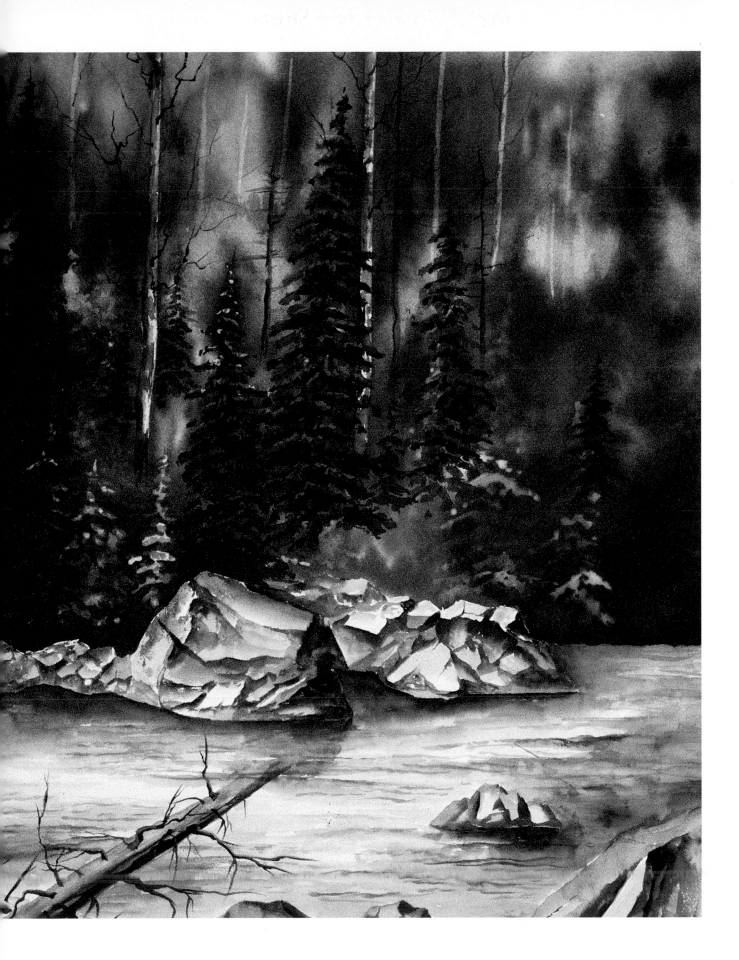

MAKING TRANSITIONS WITH MOUNTAIN VEGETATION

To reach the higher climes of mountains, one must first make one's way through the dense varieties of undergrowth in meadows and mountain basins and through tall stands of pine and aspen groves that rise from the rich soil, which is abundantly watered by streams and springs.

This greenery, which dresses the mountain slopes and valley floors, ranges from delicate mosses and tender grasses to the tiny wild flowers and larger-leaved plants, to shrubs and meadow willows, to quaking aspen and majestic pines. Though this variety of plant life varies greatly in size, color, and permanency, it exists in delicate harmony within the ecological system with rocks, water, and weather.

Often there is a subtle transition from one type of plant life to the next. On some occasions, there is a radical jump from one species and one size to the next. Plush meadows are surrounded by tall silver firs, and harsh rocky crags are softened by clusters of magnificent flowers. The multiple colors found in mountain vegetation are enhanced when contrasted with the grays and browns in the rocks and the mountain itself. It is strange yet wonderful how the massive permanence of rock is so closely linked to the frail and perishable plants and wild flowers that grow among its broken ledges. I paint most kinds of vegetation with watercolor inks using a small pointed sable brush. However, some distant vegetation can be suggested by using the dye transfer method of painting.

From June through September, the lower elevations display a great variety of greens, including meadows with their long grasses, various shrubs, and blue spruce trees along the lower slopes. Often these warm colors are contrasted with distant peaks still covered with snow. I used the dye transfer method for the sky and mountain range. I painted the dark foothills and vegetation with transparent inks.

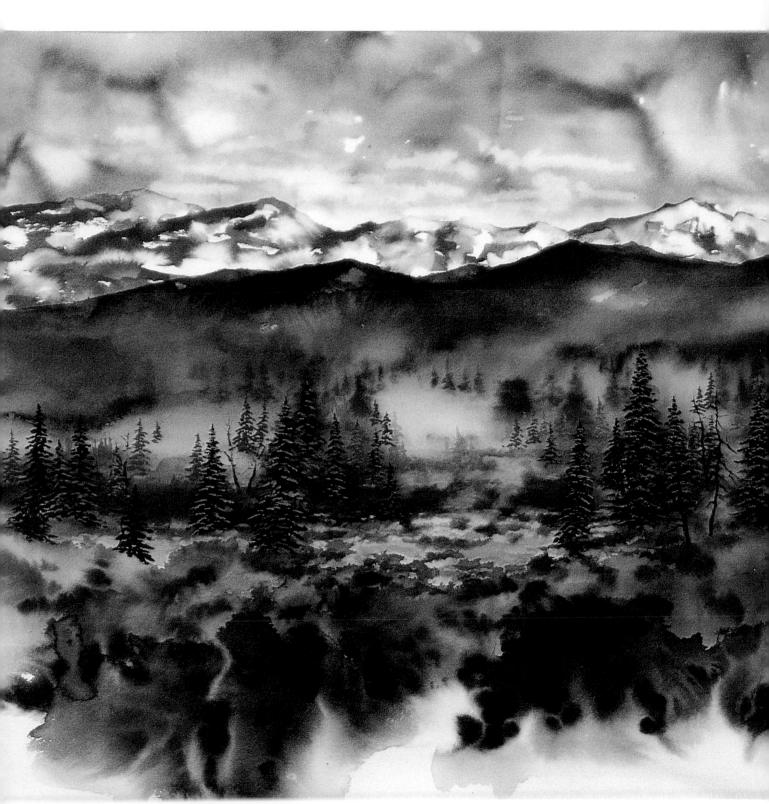

SOUTH PARK, dye color and watercolor ink on watercolor paper, 14″×16″ (35.5×40.6 cm).

Mountain Vegetation: Rendering Willows and Pines

When I am painting a cluster of shrubs or a single bush, I first moisten the designated area on the watercolor paper and begin to brush the lightest values of yellow and green watercolor ink on the upper portion of the dampened paper. As I move from top to bottom, I darken the value of the hues until the darkest color contacts the ground area. Before the ink has dried, I add drops of clear water containing a small amount of bleach to lighten certain areas. After the color has dried, to create the sense of texture and highlights, I spray a weak solution of bleach and water onto the color with a spray mister.

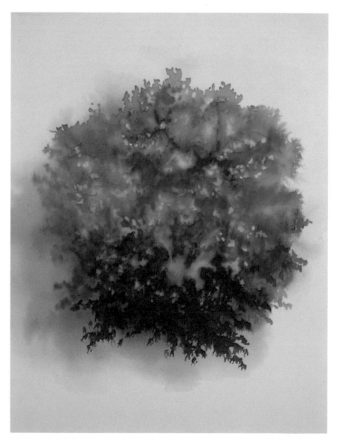

MOUNTAIN WILLOW, watercolor ink on watercolor paper, 8″×10″ (20.3×25.4 cm).

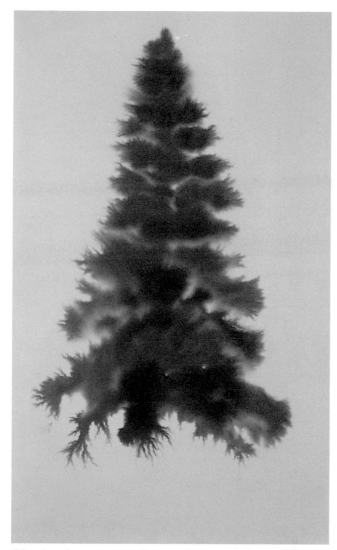

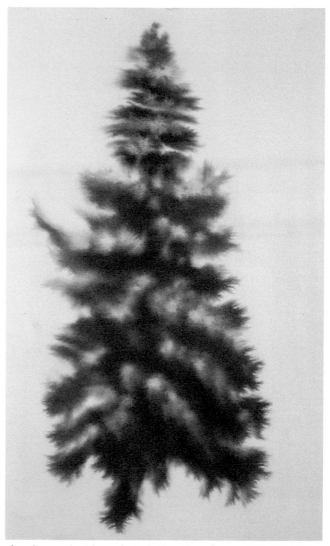

First I moisten an area of watercolor paper before applying the watercolor ink. I mix equal amounts of green, blue, and orange inks and apply them with a small brush, knowing the ink will spread rapidly on the moist watercolor paper. When the painting of the tree is completed, I dry it immediately to stop any further spreading of the ink.

Another method I use in painting pines is to add highlights to the branches by adding a weak solution of bleach while the watercolor inks are still moist. This also gives more dimension to the tree.

Here are the three colors I used for the painting above: burnt orange, cobalt blue, and cadmium green. At the center, note how these hues blend.

Mountain Vegetation: Painting Light Elements Against Dark

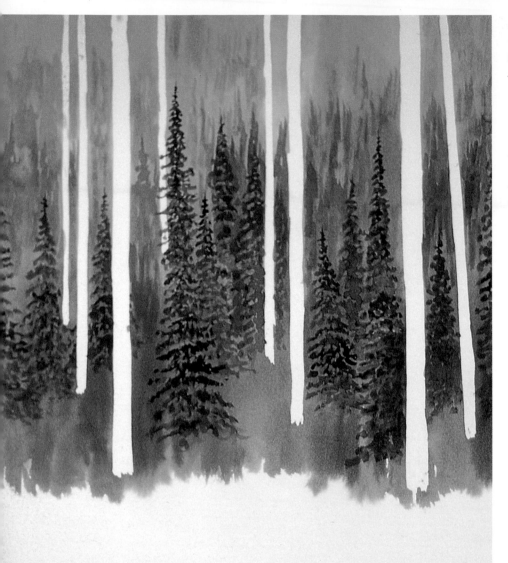

Before painting in the background vegetation, I masked off the foreground aspen trunks with Grumbacher liquid frisket so that they would not be penetrated by the watercolor inks. When the background dried, I painted in pine trees at a middle distance with watercolor paints, since the thickness of the paint lends itself to more minute details that will not diffuse into the background. Later, I removed the frisket, painted the aspen trunks, and added the limbs.

The rock-strewn gorges that form the paths of the streams are usually lined with vegetation of many kinds. In western Colorado and northern Wyoming, this growth consists of tall grasses, willows, saplings, aspen, and pine trees. The density of the forest is a beautiful backdrop to the clear rushing stream. The light aspen trunks and leaves stand out against the dark green of the pines. The distant foliage provides an escape for the eyes from the larger foreground trees. I painted the stream and rocks with Winsor & Newton watercolors. For the background, I used watercolor ink for the more distant trees and watercolor paints for the more detailed frontal trees at the edge of the forest, since it is more viscous and controllable. I masked out the aspen trunks with liquid frisket prior to painting the other trees.

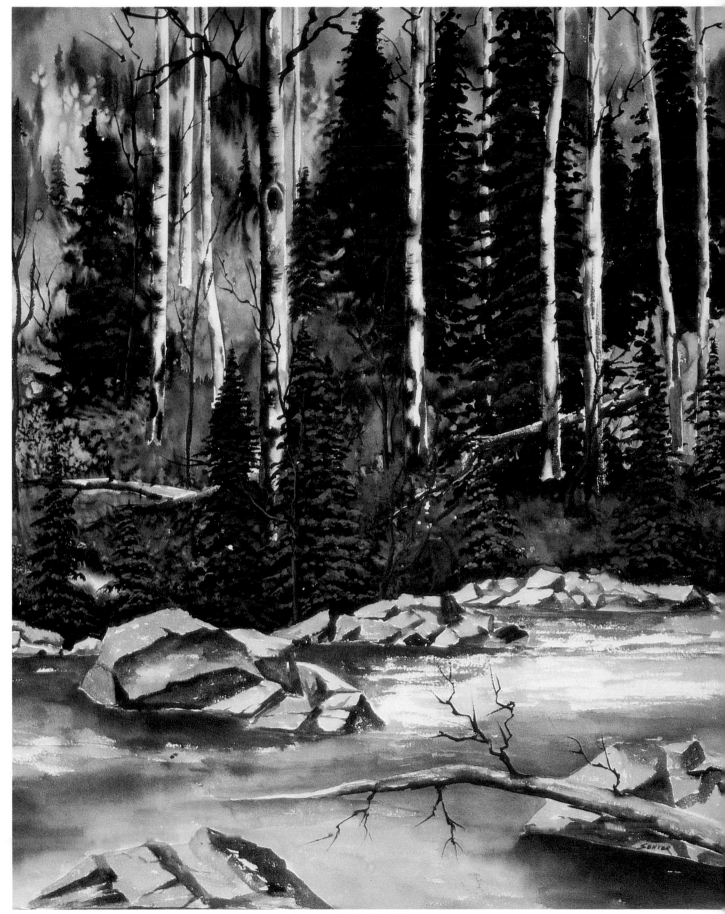

COTTONWOOD CREEK, watercolor ink and watercolor paint on watercolor paper, 16″ × 20″ (40.6 × 50.8 cm).

Mountain Vegetation: Autumn Foliage

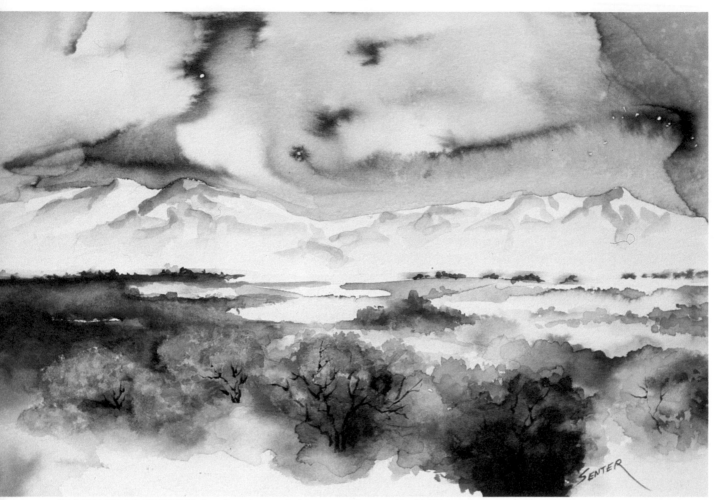

FALL WILLOWS AND FIRST SNOW, dye color and watercolor ink on watercolor paper, 10″×14″ (25.4×35.5 cm).

The first snows of the fall in the mountains provide a beautiful background for the changing leaves on the aspen and meadow willows. It is an interesting paradox that as nature begins to turn the multicolored mountains into a neutral white, it at the same time changes the trees and other ground cover into brilliant reds, oranges, and yellows—a sense of coldness and warmth prevailing at the same time on the earth. I used the rice paper transfer method for the dramatic sky, which produced the snow on the distant mountains. I lightened the area with a weak solution of bleach. By adding bleach to the sky area after it was dry, I formed the mountains. The remaining portion of the painting was done with watercolor inks.

From left to right, the colors I used for the painting above are ice green, cadmium yellow, and moss green.

Mountain Vegetation: Combining a Wealth of Textures

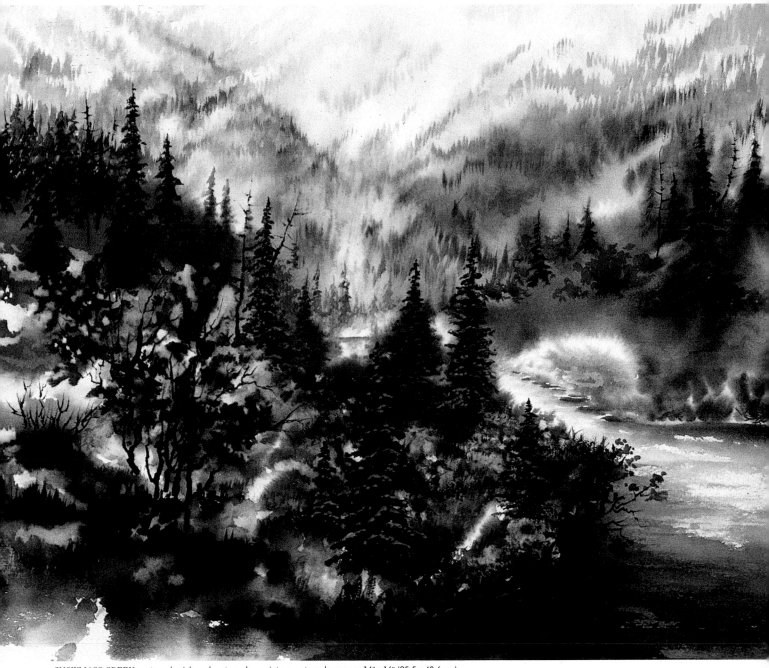

SNOWMASS CREEK, watercolor ink and watercolor paint on watercolor paper, 14″×16″ (35.5×40.6 cm).

Not all of a mountain's vegetation is separated with neatly defined limits. More common is the mountainside with a cluster of many types of foliage intermingled and scattered among the rocks. Such an environment is often difficult to traverse owing to the tangled undergrowth. It can be so difficult to get through that mountain climbers often have to detour. Here, I have contrasted the rather chaotic, textural foreground with the more serene, orderly background. I used watercolor inks for the background, since they lend themselves to creating a more vague impressionistic environment with their flowing liquid colors. Winsor & Newton watercolors were used for both the middle ground and foreground because these more dense pigments are better for painting sharp-edged details. More distant areas in my paintings are always painted with either dye markers or transparent watercolor inks, plus a bleach solution if I want to suggest fog or cloud formations.

DEPICTING THE DIVERSITY OF WATER

Mountain water systems include springs, melting snow, high lakes, and streams of every size. These streams flow through every conceivable type of landscape from their point of origin in drops of melted snow in the high glaciers to the great rivers they empty into far below. They pass through boulder fields and grasses above timberlines to the great glacier lakes separated by leaping cataracts and tumble down with an ever-increasing speed through gorges and canyons, through tundra and pine forest, out onto meadows and prairies where the water slows its frenzied pace and flows in deep, silent, moving channels.

The inclusion of water in a painting helps to set the mood of the painting. It can project a somber mood with its dark, brooding color, or it can produce a sense of joy as light is shown dancing across its surface. Though the painting of water may prove to be frustrating at first, the effort to learn its secrets is well worth the time of trial and error for the serious watercolor painter. It can be a great tool in your expressive arsenal.

For me, the challenge of painting water in all its diversity is the most fulfilling problem-solving event I can encounter in my work. It is perhaps the most difficult subject matter a painter will face owing to its ever-changing response to light and shadow and to its moist, transparent characteristics. Some bodies of water are of a solid color; others show a multiplicity of reflections from surrounding images. Still others reveal their depths and display distorted images of rocks and sunken tree limbs. Some contain all of these characteristics at the same time.

To become proficient in rendering water, an artist must exercise great concentration when studying the movement or the stillness of a body of water. The constantly changing colors and color shapes can make it a dizzying experience for the painter unless he or she can learn to isolate each facet of the water's reflections in his mind's eye. To express the vicissitudes of water's moods, I believe a transparent medium, such as dye color or transparent watercolor inks, is best. Sometimes both of these media combine to fully express the fluidity and unique color qualities of water.

This painting is in a horizontal format to emphasize the width of the stream and to show its slow movement. The distant mountain range, which is low on the horizon, reinforces the size of the stream. The sky was done using the dye transfer method. I used watercolor inks for the landmass, trees, and water. The water was painted with several shades of blue and applied with a large ink-loaded Chinese brush. With bleach I lightened the mountain peaks to push them a maximum distance from the foreground.

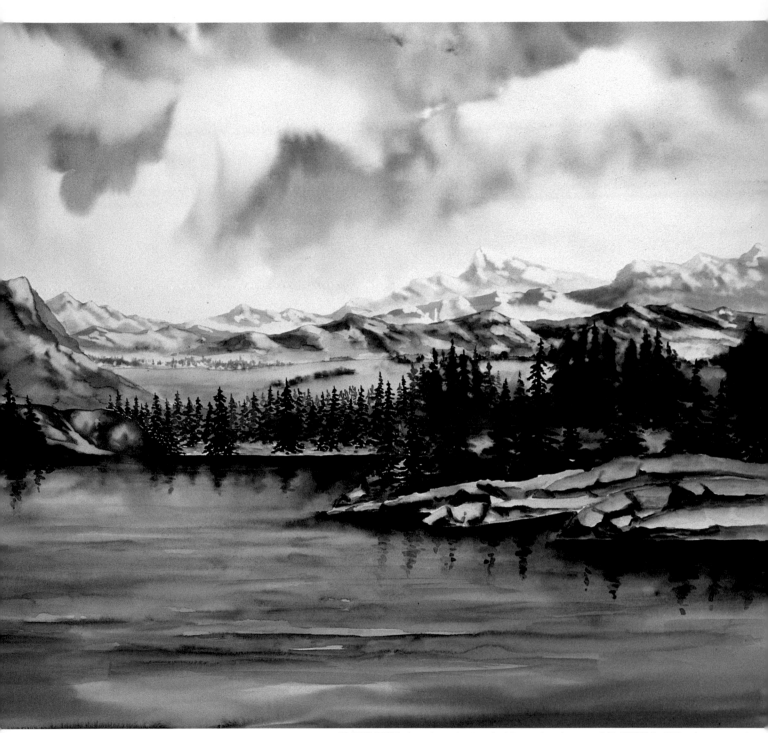

PLATTE RIVER, dye color and watercolor ink on watercolor paper, 14″ × 19″ (35.5 × 48.2 cm).

Water: Painting Reflections

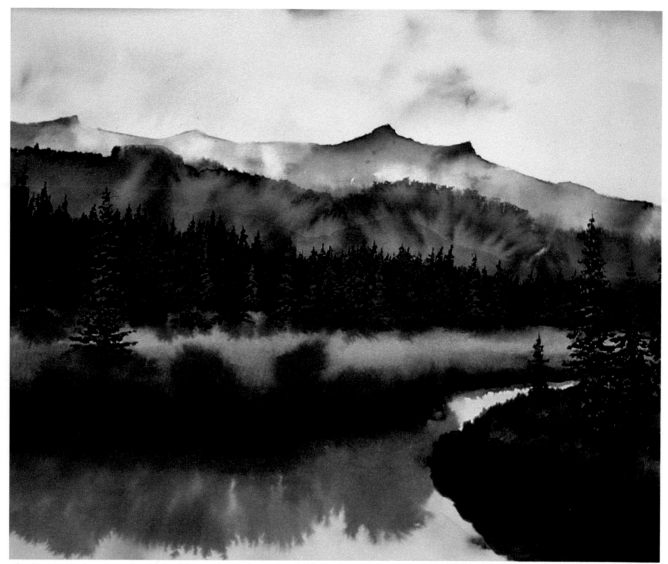

BEAVER CREEK, dye color and watercolor ink on watercolor paper, 12" × 14" (30.4 × 35.5 cm).

Depending on the time of day, the angle of the sun, and the quality of light, trees and bushes can cast reflected images several times their actual size on a still pond or silently moving stream. The actual foliage may appear to be dark and rather two-dimensional in form, yet when seen reflected in the stillness of clear water, its every hue is revealed and its proper dimension seen. In Beaver Creek, the reflections on the water are the subject matter, with their distorted size and beautiful color. The setting is serene and quiet. It is late summer—the meadow grasses are turning to a golden yellow and the willows are growing warmer in hue. A quietness and beauty prevail that distinctly differ from earlier months. I used the dye transfer method in the sky and distant mountains. For the middle-ground hills, vegetation, and water I painted with watercolor inks. After painting the stream the same color as the sky, I allowed it to dry. Then I gently remoistened it with a soft brush and placed yellow and green inks at the upper edge of the stream, allowing them to mix and run downward to a position that almost covered the entire surface of the stream.

Clear alpine lakes mirror the surrounding mountains and the color and cloud formations of the sky. Smith Lake, west of Lander, Wyoming, can be reached after an hour's drive and a seven-mile walk over several mountain peaks and through dense forests. Surrounded by timber and large boulders, the lake is very deep, dropping forty feet at its outer rim. Large rainbow and Mackinaw trout cruise its shoreline. I used the dye transfer method for the sky, distant mountains, and reflection in the water, and painted the middle-ground hills and the foreground trees with watercolor inks.

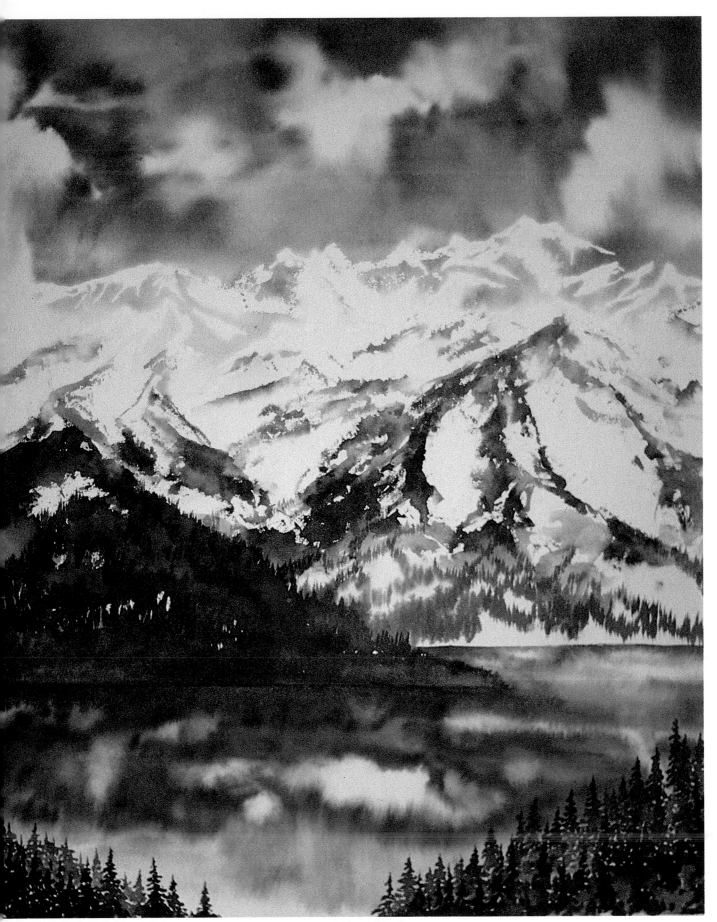

SMITH LAKE, dye color and watercolor ink on watercolor paper, 14" × 18" (35.5 × 45.7 cm).

Water: Expressing Fluid Movement

Some of the most difficult water to reproduce is water in motion. The artist does not have the luxury of studying the reflections and color shapes of a still pond or lake. A kaleidoscope of color in motion passes before us when viewing a rushing mountain stream. The white water that forms when the current throws the water against protruding rocks in the stream, or the small waves that culminate at the water's banks, and the multiplicity of twists and turns and the variation of the water's speed—all of this makes painting water a real problem-solving occasion. It helps to work from photographs and slides, since the elements are frozen for closer inspection.

What caught my eye was the white water that mountain streams produce as their fast-running water smashes into large boulders or timber fallen in the stream. To render this experience in a painting, I placed the emphasis on exposing a great deal of white paper to suggest the churning water. I used watercolor ink in this painting because I wanted the color in the painting to be more intense. Some of the watercolor paper was left exposed from the start, and some of it was exposed by scraping with a razor blade.

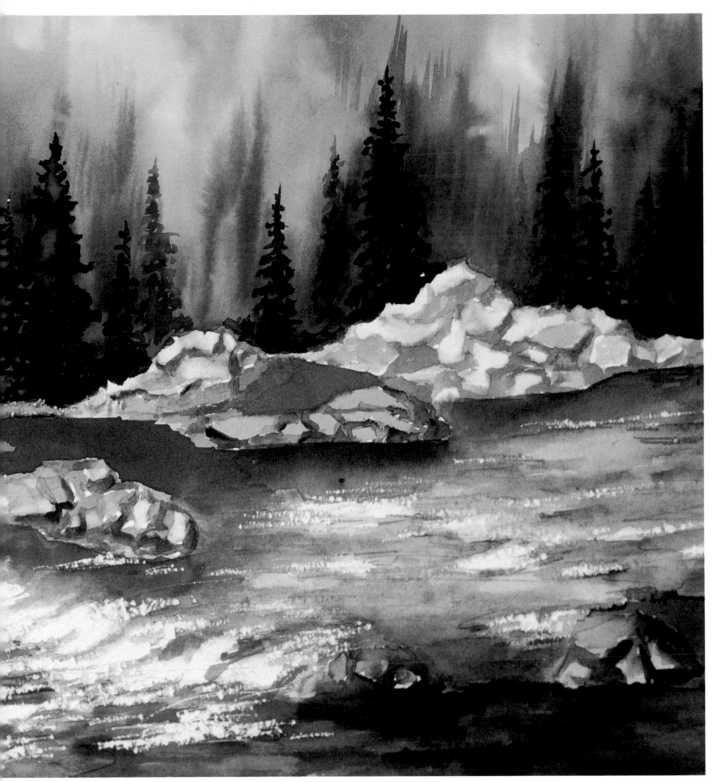

WHITE WATER, watercolor ink on watercolor paper, 8″ × 10″ (20.3 × 25.4 cm).

Water: Rendering Submerged Rocks

When you look at objects beneath the surface of the water, there is the sense of distortion. Many factors determine the degree of this distortion. The quality and angle of light entering the water will twist and deform various tree limbs and rocks. The physical position of the viewer will make a difference in how objects are perceived. The stillness or slight movement of the water's surface will bring a variety of degrees of distortion to underwater images. Generally, objects seen beneath the water tend to look slightly smaller than their actual size, and their color is seen as darker than when viewed in open air.

To depict submerged rocks in a stream or lake, first render the stones in color similar to the color of the water that will cover them. Watercolor inks or watercolor paint can be used for this. Remember to keep the rock shapes rather flat, since this distortion is common for submerged objects. When the rock shapes have dried, a sheet of rice paper covered with the desired color of the water is placed over the entire surface of the watercolor paper and moistened with a large brush. Distant water can be lightened by applying a weak solution of bleach and water.

To give the illusion of rocks under water, I first tore rock shapes out of a sheet of rice paper, leaving the jagged edges that suggest their uneven surface. Then I placed black and brown dye color from dye markers on each torn piece of rice paper. While they were still dry, I placed them on the watercolor paper in the positions I desired. Using a small brush, I carefully placed water on each piece, being careful not to allow the moisture to extend beyond the rice paper images. When the color had been transferred to the watercolor paper, I lifted off the rice paper pieces. A weak solution of water and bleach was then daubed on the upper surfaces of the rocks to create a multicolor effect.

To place the rocks under water, I mixed several values of green, yellow, and orange watercolor inks and pulled the color across the rocks using a six-inch-wide brush. The moisture tended to soften the rocks' edges. This step was done quickly to eliminate individual brushstrokes and to separate drying times for each area of the paper. While the watercolor ink was still wet, I added a darker hue near the lower part of the picture plane to suggest more depth to the water. When the painting had dried, I dipped a brush in clear water and pulled it across the surface in several places.

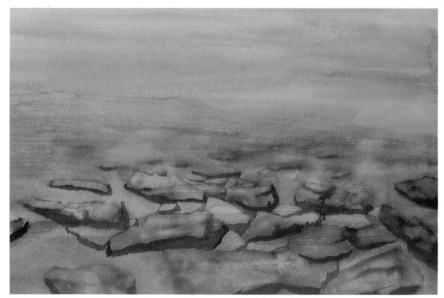

ROCKS AND WATER, dye color and watercolor ink on watercolor paper, 10"×14" (25.4×35.5 cm).

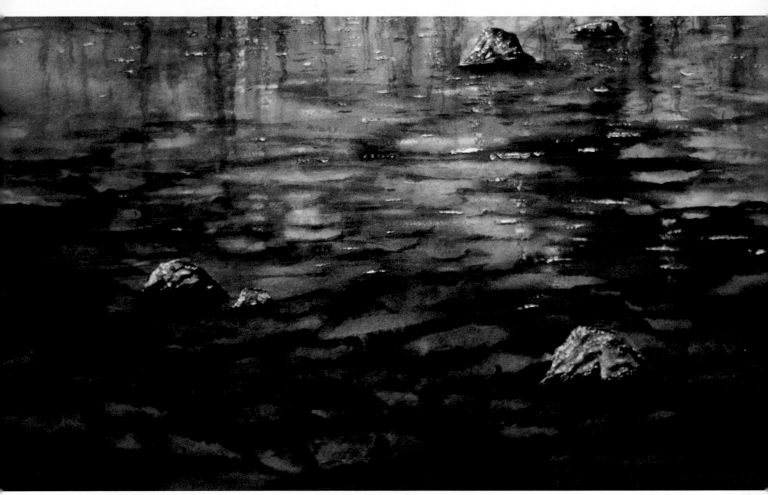

ROCK BOTTOM, dye color and watercolor ink on watercolor paper, 12″ × 16″ (30.4 × 35.5 cm).

This painting contrasts the vertically oriented rocks sticking out of the water with the flat rocks beneath the water's surface. Although they are the same rocks, they seem quite different. Working with a rather limited subject matter makes composition very important. In Rock Bottom *I varied the dark and light areas of the painting to create interest. I painted several rocks above the water and many under the water. I added small spots of light to suggest the light reflections and tiny particles floating on the surface of the water. A small area at the upper-left corner of the painting suggests a reflection of a form of vegetation near the pond. There are a number of moods here, from the somberness of the dark foreground rocks in deep water to the rocks in the shallows whose surfaces are penetrated by the light flowing through the water. I first drew most of the rocks in the composition on the watercolor paper to guarantee a good distribution of form. The rocks that were to protrude above the surface of the water were masked out with liquid frisket. Then I painted directly onto the watercolor paper with watercolor inks, being careful to make the rocks on the lower part of the picture plane darker than those higher up. To unite the rock shapes positioned underwater, I placed several shades of green and yellow dye marker color on a sheet of rice paper and bled it through to the watercolor paper. When the moist color came into contact with the rocks painted with ink, the ink bled slightly at its edges, which helped to blend the rocks together. When the painting had dried, I used a six-inch-wide brush to pull a light green layer of watercolor ink across the entire surface. While this was drying and unifying the composition even more, I daubed a thin, wet strip of color-saturated rice paper onto the painting in the upper-left corner to create the light reflections in the water. Then I dried the painted surface with a hair dryer to keep the images from dissipating beyond recognition. This subject matter can be difficult to complete successfully, but often proves worth the effort.*

Water: Painting a Lily Pond

It is complicated enough to paint all the characteristics of a quiet pond without adding the vegetation growing on the surface of the water. This addition affects the condition of the water because of cast shadows and reflections in the water. Here, the lily pads seem to be suspended above the water because of the brightness of their color compared to the soft reflections in the water. I masked out the lilies with liquid frisket before I painted the water. A sheet of rice paper was covered with several hues of light blue, green, gray, and brown and allowed to bleed onto the moistened watercolor paper, where the colors spread and blended together. While the painting was still damp, I pressed a strip of yellow and brown dye-colored rice paper onto the upper-left corner to show the reflection of nearby vegetation. After removing the masking material, I painted the water lilies with green and yellow watercolor inks.

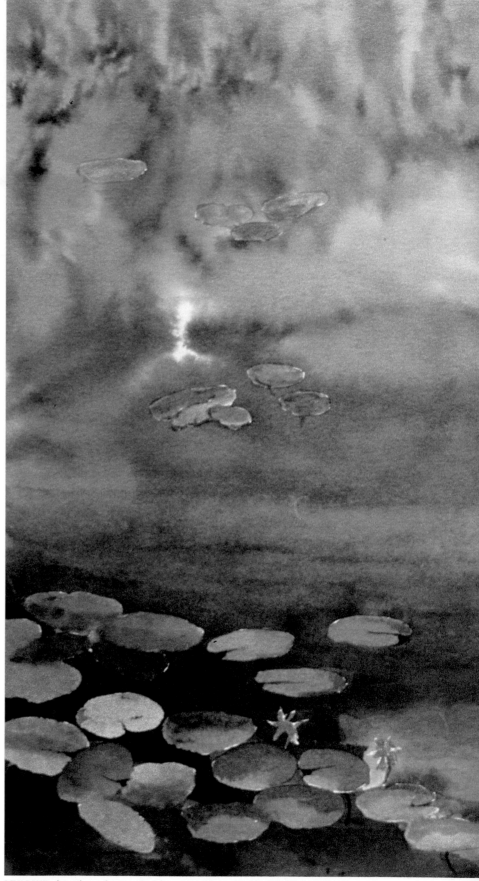

LILY POND, dye color and watercolor ink on watercolor paper, 12″ × 14″ (30.4 × 35.5 cm).

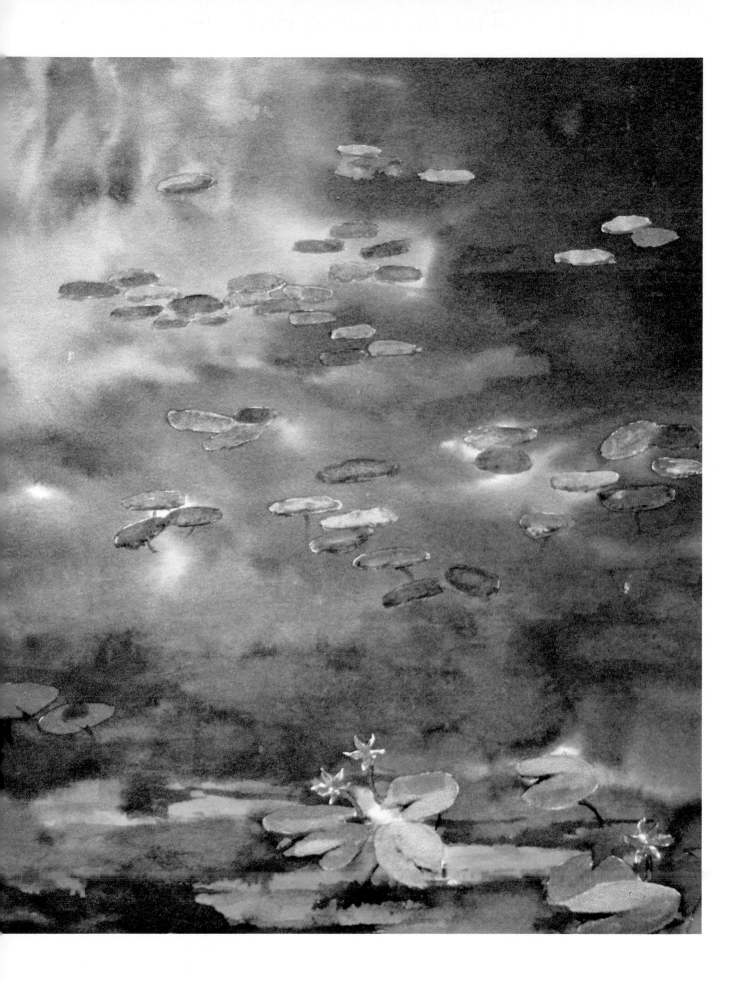

Water: Conveying an Underwater Environment

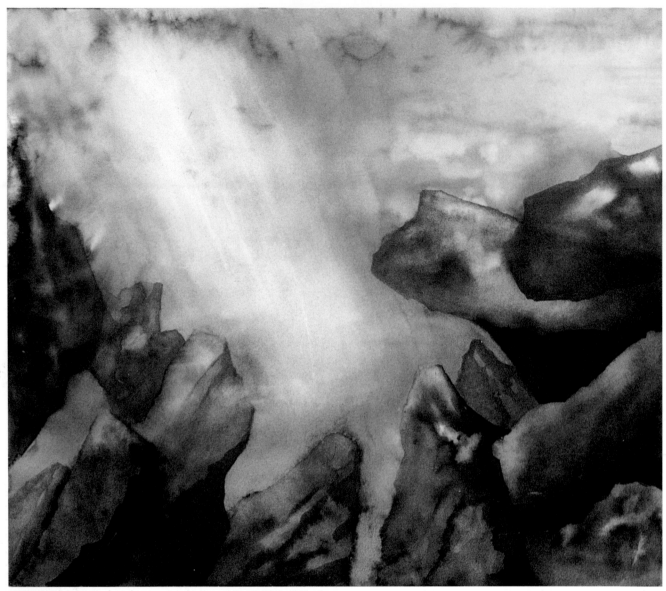

DEEP WATER ENIGMA, dye color on watercolor paper, 14″ × 18″ (35.5 × 45.7 cm).

Common rocks, when placed under water, become distorted in size, color, and shape and can create a place of mystery and intrigue in the depths of a crater lake. Beams of light stream through the surface of the water and illuminate the environment with an eerie gleam that transforms the rocks into uncertain images with arresting qualities. In this painting, I have placed the viewer under the water looking toward the surface. Most of the rocks are shadowed, and a few are bathed in light. In painting this picture, I first tore rock shapes from rice paper and placed brown, black, and blue dye colors on the pieces. I then placed the rock images on watercolor paper in the positions they would occupy. I added moisture to the rice paper pieces to blend the colors and bleed them through to the watercolor paper. When the rocks were dry, I placed a sheet of rice paper covered with blue and black dye color over the entire watercolor sheet and bled the color onto the painting. This color application produced the top-water that reflects the sky and softened the hard edges on the rocks as well as giving them a layer of color found in the water.

Shafts of light pierce through the bouldered walls of a glacier lake, where trout cruise the shoreline in search of insects. Water's movement, color, and light must be expressed spontaneously. I made this painting much the way I did Deep Water Enigma, *opposite, but I first masked out the image of a trout with liquid frisket and then later painted it with watercolor paint. Last, to unify the composition, I placed a full sheet of rice paper colored with light blue and black dyes and bled the color through to the watercolor paper using a wide brush.*

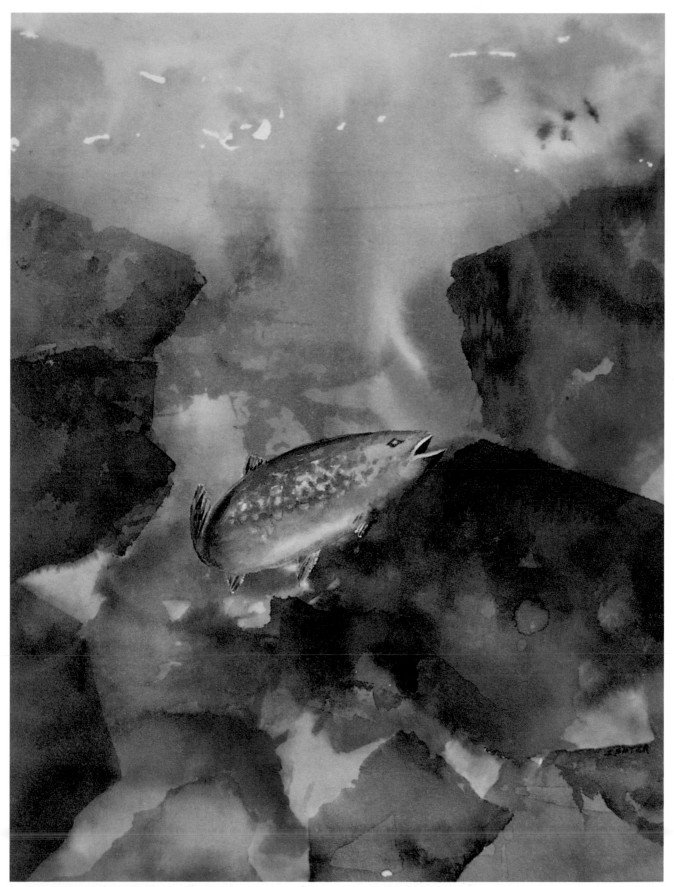

GLACIER LAKE BROOK TROUT, dye color and watercolor paint on watercolor paper, 10″ × 12″ (25.4 × 30.4 cm).

PULLING LANDSCAPE COMPOSITIONS TOGETHER

The very nature of the dye and transparent ink mediums lend themselves to an interpretation of an impressionistic style. Their extreme fluidity naturally blends images together and presents the landscape as a unit rather than as so many parts. Presenting landscapes as images involves a great deal of planning prior to the execution of the painting. There is usually no second chance if the first attempt fails, since the best approach is to present the color in such a way that large sections of the painting are completed all at once. Knowledge of the medium is of great importance if you are going to control it successfully.

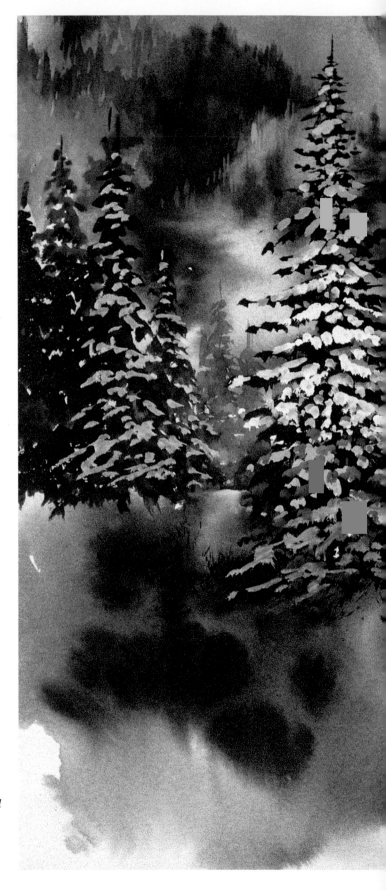

I have been in the mountains many times when cloud banks hovered just above the ground in meadows and low places in the mountainous environment. The soft, pliable clouds contrasted with the stately evergreens and seemed like steam seeping from fissures in the earth. The multiple invading clouds with their amorphous influence add mystery to the scene. The range of light runs from brilliant sunlight to a blackness found in deep shadows. My intent was to express a moment in time when the sky stretched its boundaries to earth, where it mingled among earthbound elements, changing them magically. After various shades of blue and black dye had been bled through rice paper to a moistened sheet of hot-press paper, I introduced bleach to form the soft-edged clouds. Pine trees of various sizes, painted in with watercolor inks, gave some semblance of reality to the scene.

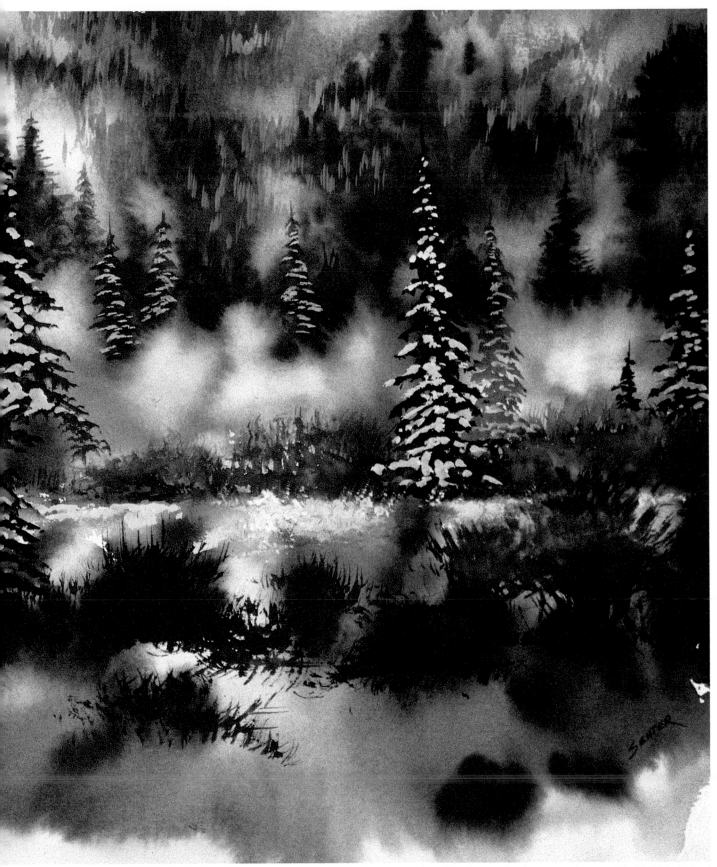

FALLEN SKY, dye color and watercolor ink on watercolor paper, 12″×14″ (30.4 × 35.5 cm).

Taking an Impressionistic Approach

Though the elements of nature are diverse in size, shape, color, texture, weight, durability, and function, when an impressionistic approach to landscape is desired, these elements must be presented in such a way that they flow together to make a statement about their unity and mutual dependence on one another. Attention to detail must give way to broader generalizations.

A number of natural conditions cause us to see a landscape as an impression rather than so many separate entities. Limited light, low-hanging clouds, fog, and mist tend to cause landscape elements to fuse together by softening their edges and blending their colors. This sense of transition between the various elements unites them into a less complex statement.

My deepest emotional responses to nature are brought about by what I call enigmatic environments. These are places where nature's elements are intermingled, creating an ambiguity that seems almost mystical to me. The quality of light plays a big part in creating these deceptive areas of unintelligibility, where two of nature's elements such as water, land, sky, and vegetation meet. Water from a stream running under the stream's bank; water disappearing under the ledge of a rock; clouds and mountain peaks enshrouding one another; and rocks disappearing in the dark abyss of deep waters . . . these and other situations are profound in my view and give nature a mystique that defies complete understanding while enriching imagination.

The technique needed to produce such soft and evocative impressionistic paintings can be best achieved using dye markers and watercolor inks. A dye marker sketch on a sheet of rice paper can be turned into an impressionistic painting by placing it on a sheet of unmoistened hot-press paper and bleeding the colored images onto the paper using a wide, moistened brush. The key to success in this technique is applying the correct amount of moisture. There must be just enough water in the brush hairs to wash the color through the rice paper and cause it to blend and spread slightly when coming into contact with the watercolor paper. I use this method of painting to produce an overall color field that I can further enhance by placing dye from markers directly on the moist watercolor paper or paint into the transferred dyes from watercolor inks. But it is somewhat difficult to produce details, color intensity, or dark values using this rice paper transfer method, since by the time the dye color reaches the surface of the watercolor paper, the moisture and bleach in the rice paper itself have already thinned and weakened the dye color.

Another method of creating landscape images is to draw directly on the surface of a soft hot-press watercolor paper with Staedtler Mars Graphic markers, which have flexible tips. The dye from these markers is more fluid than in other dye markers and will spread when moisture is applied to them. When you have completed every detail of the drawing, use a four-inch-wide Chinese brush to draw water across the watercolor paper, starting from the top and moving downward. If you apply an even coat of light moisture, the dye colors in the drawing will blend and bleed into one another to produce a sensitive landscape impression.

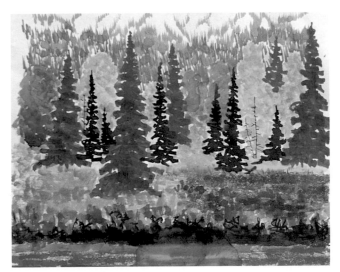

Dye marker drawing on rice paper.

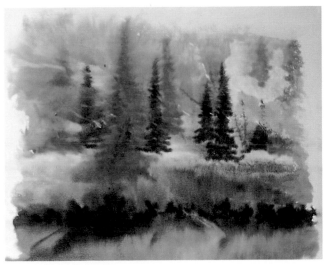

The dye-colored images are bled through the rice paper to the surface of a dry hot-press watercolor paper. The correct amount of moisture is of importance when employing this method of painting. This process is meant to be preliminary to further refinements, since the images that appear on the watercolor paper are vague.

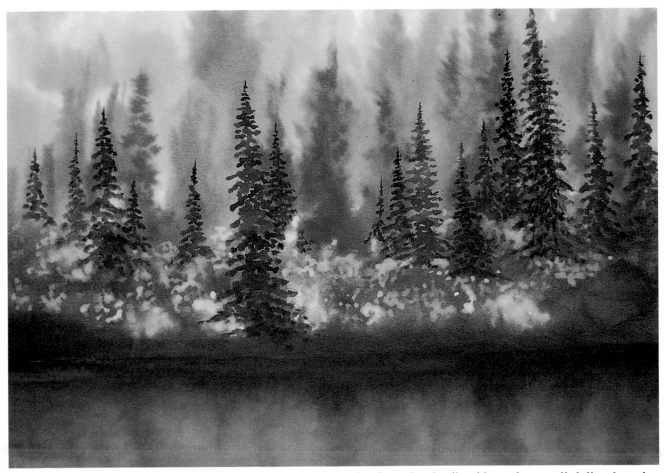

After the atmospheric background painting has dried completely, I define a few details with markers applied directly to the watercolor paper.

Dye markers were used to draw directly on porous watercolor paper.

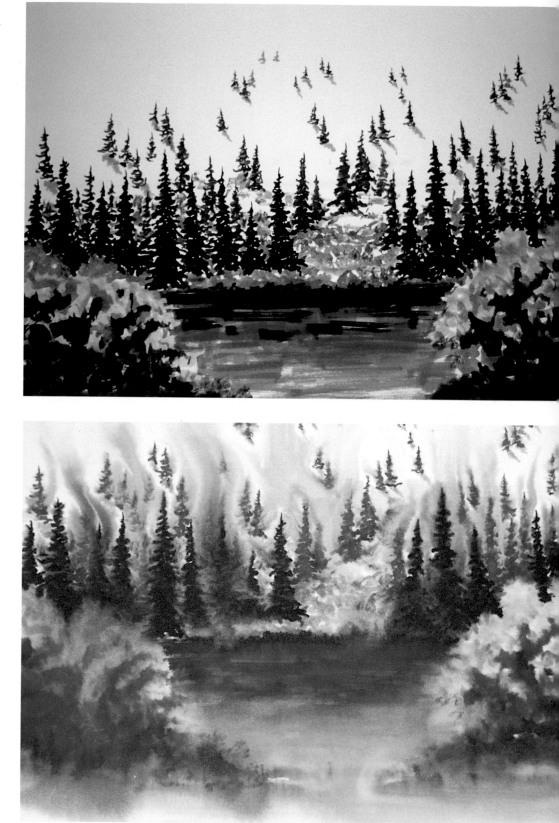

I applied moisture to the drawing with a wide brush and let the painting blend and dry at its own rate of speed or until the painting gave the desired effect.

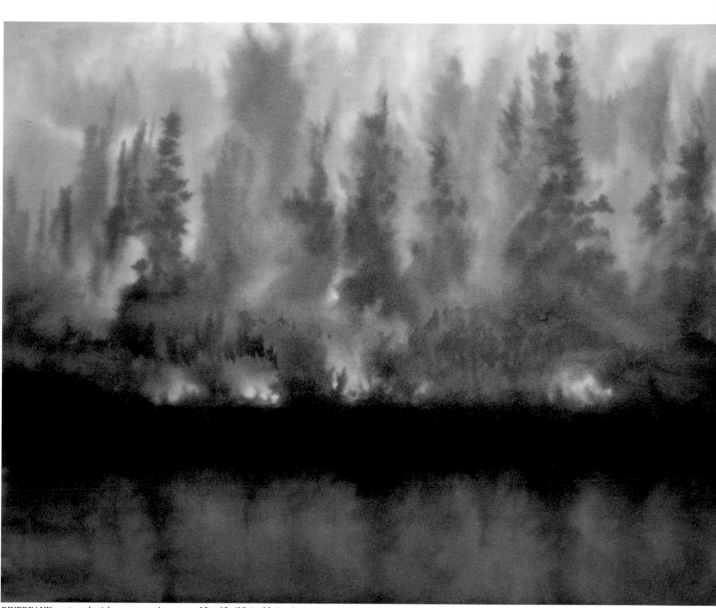

RIVERBANK, watercolor ink on watercolor paper, 10″ × 12″ (25.4 × 30.4 cm).

As a boy, I used to catch fish and frogs with my hands by carefully feeling the underside of rocks and under dark banks of streams. I remember feeling some apprehension about reaching into areas I could not see with my eyes. My main concern was not to encounter a snake lurking in some hidden place. This small painting illustrates the enigma of a stream meeting its bank and becoming indefinite in clarity. The shoreline and the waterline become one in their dark, impenetrable environment. Because of this inaccessible place, the painting does not have to be complex. The uncertainty of what we see holds our attention. To emphasize this enigmatic statement, I painted the background trees with little detail and the foreground water without motion. Watercolor inks were used in developing the environment.

From Abstraction to Definition

When an artist uses painting mediums such as dye and ink, he exercises the imagination continuously owing to the extreme fluidity of the colorants. He has to be alert to the tendency of these media to blur and obscure various forms and outlines of specific details in nature. The process of creating an ambiguous field of color that can be manipulated in a way that will produce a recognizable landscape is perhaps the most difficult process in working with dye and ink because these media can appear too impressionistic. If an area of clarity and sharp contrast is needed, watercolor paints can be helpful.

The difficulty with this painting preparation is that it is an intuitive act rather than something that can be carefully planned. You must have a sense of what you want to express about nature before you commit color to watercolor paper. Developing this color field involves a combination of decisions about colors, placement, and dampness of paper. Once you've prepared your general plan, you can begin to make your initial, intuitive commitment of dye or ink, or both, to paper. If the color-blending process is successful and the free-flowing hues begin to form images suggestive of landscape, you're on your way.

Usually I prepare three sheets of rice paper loaded with sky color, middle-distance color, and darker foreground color. I place these simultaneously on moist watercolor paper, applying moisture to the rice paper pieces with a wide wet brush. I allow them to bleed onto one another and to expand across the paper. If I see that an area of color will lend itself to being transformed into landscape imagery or an environment, I dry that area immediately so that it won't expand beyond recognition.

When producing a color field with watercolor inks, I first moisten the watercolor paper and then lay several colors from a large brush into an area all at once, allowing them to blend and disperse freely. This produces an interesting background for painting or evokes specific landscape elements.

When I am satisfied with the abstract areas of color, I immediately draw with dye markers or paint with ink into the wet surface to develop more realistic shapes where there were only suggested ones. I do this quickly because the paper absorbs the moisture very rapidly. On occasion, I'll moisten the watercolor paper for the second time, though this usually alters existing images. I have sometimes placed several layers of color on top of one another with some success, but ideally I like to complete the painting with only one application of underpainting.

After an impressionistic expression has been produced and dried, I add details, such as tree limbs, rocks, or other types of vegetation, to the dried surface with small, pointed dye markers, watercolor ink, or watercolor paint, using small sable brushes.

For this wooded scene, I used transparent watercolor inks. The watercolor paper was heavily moistened before applying any ink. I then painted various shades and intensities of green and yellow inks on several positions and allowed the inks to spread and bleed into one another to produce new combinations of color and form suggesting tree groupings.

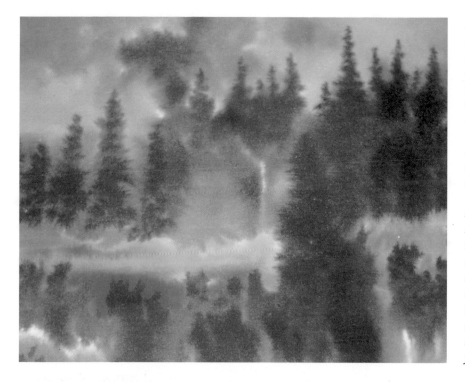

In this series of steps, I cannot develop the original color field, since slides must be made of each step, and the color dries before I can begin to develop it into recognizable elements. The first change I made was to define the tops of some of the trees and establish an area of water. This had to be done while the color was still wet, or all the images would have hard edges and would not recede into the background.

In this final stage of the painting, I concentrated on details when the previous stage had dried. I painted individual hard-edged trees, made the bank of the river visible, and gave a three-dimensional aspect to the foreground vegetation. The background was softened to make it appear more distant, and some white aspen trunks were formed using bleach.

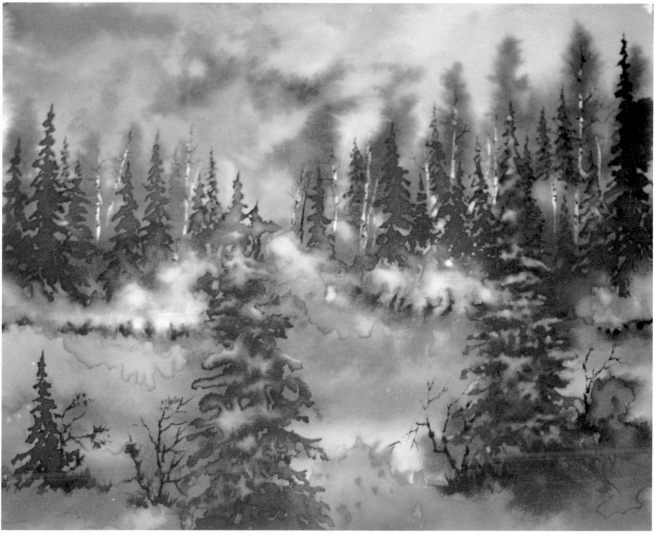

WOODLAND, watercolor ink on watercolor paper, 10″ × 12″ (25.4 × 30.4 cm).

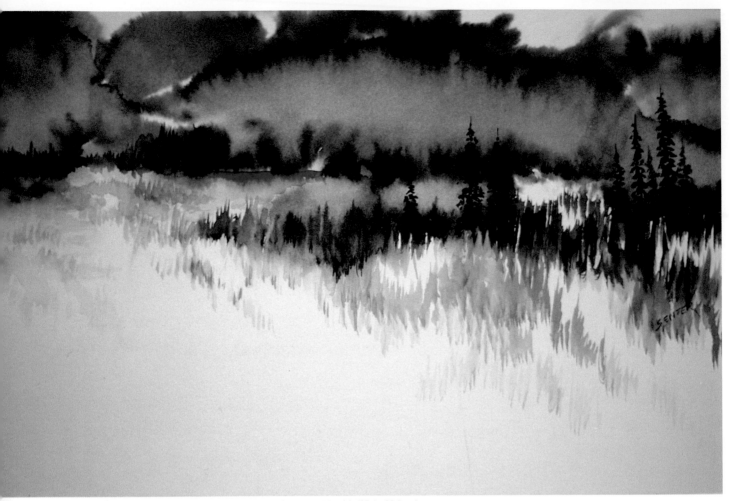

SNOW FIELD, dye color and watercolor ink on watercolor paper, 10" × 14" (25.4 × 35.5 cm).

When you are developing an ambiguous color field into a recognizable landscape, a touch of realism does wonders. Extract the trees and grass from this painting, and it would not be intelligible. The trees send signals to the brain that this is a landscape and that the distant configurations must be hills and trees against a light sky. To create this painting, I placed scraps of color-soaked rice paper on a dry area of watercolor paper and lifted them off to form the stylized formations in the background. For the trees and the foreground weeds, I used watercolor ink.

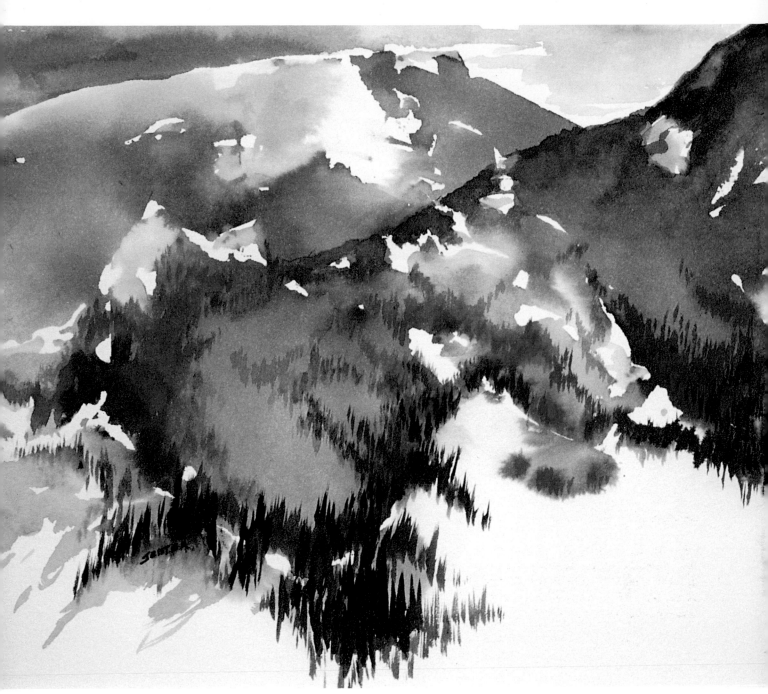

TIMBERLINE, dye color and watercolor ink on watercolor paper, 12″×14″ (30.4×35.5 cm).

I completed this austere, rather abstract painting in two steps. First, I placed a light-value dye color on a distant ridge and a darker color on the hillside at middle distance. When the color was dry, I painted the tree lines with watercolor ink. The lower portion of the painting, which features the white of the paper, defines the spatial relationship between the viewer and the landscape elements. I have tried to convey the barrenness that exists above timberline.

Combining Soft and Sharp Focus

Dye colors and transparent watercolor inks are very compatible since both are extremely fluid and susceptible to a bleaching agent. Their differing intensities of color are also complementary. The dye from markers is less intense than ink and more readily provides a soft focus. This quality makes it particularly useful for the distant images and atmospheres. By contrast, watercolor inks are brighter in hue and work well to create a sharp focus. Normally they are used for frontal details or color fields.

On occasion, you can use dye color or watercolor ink independently, as the lone medium for a painting, but I have the most success when I use them in concert with each other. Each has its own limitations, and each is applied differently, but they can collaborate to make the clearest statement.

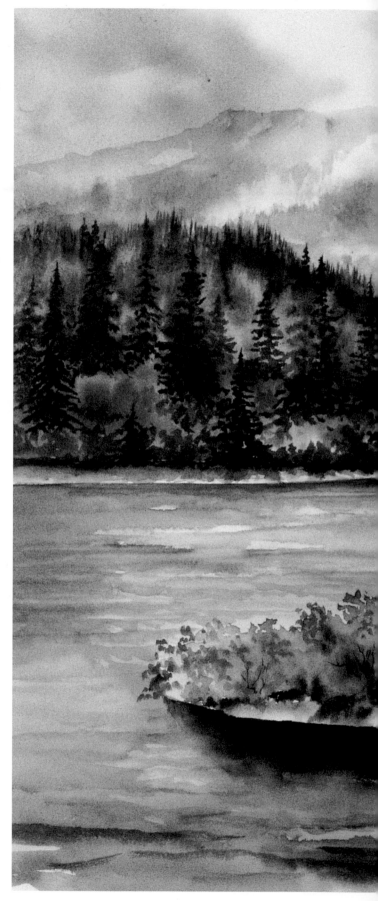

Notice how this composition strikes a balance between soft and sharp: Some areas, like the demarcation between water and land in the foreground, and many of the trees, are crisply defined, while others—transitional shrubbery in the middle ground, the mountains receding into the mist—are vague and atmospheric. These are the kinds of juxtapositions that in both art and nature hold one's visual interest.

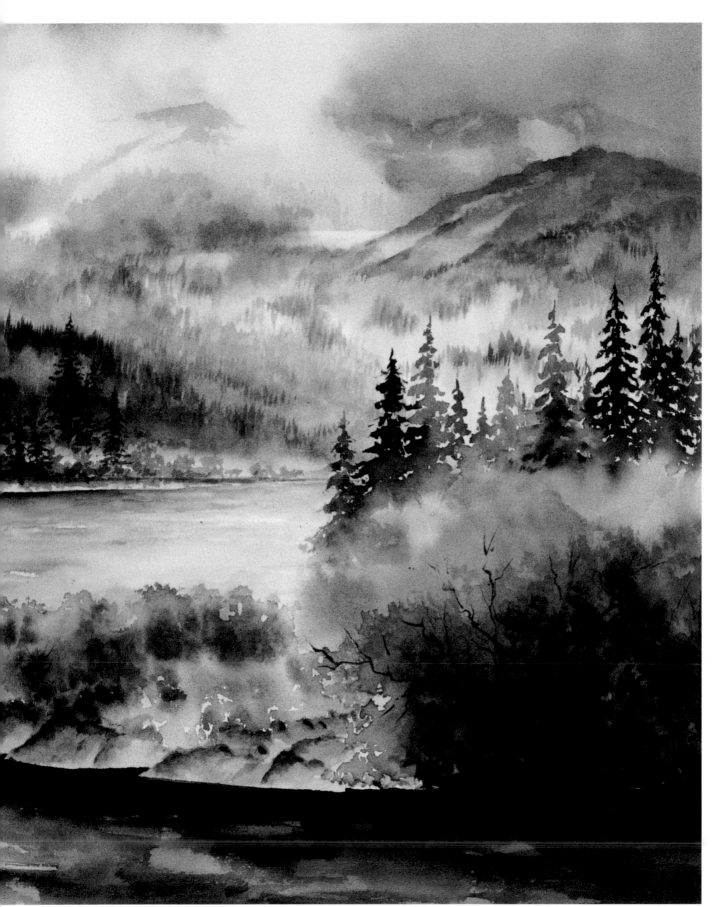

OCTOBER GOLD, dye color and watercolor ink on watercolor paper, 12" × 16" (30.4 × 40.6 cm).

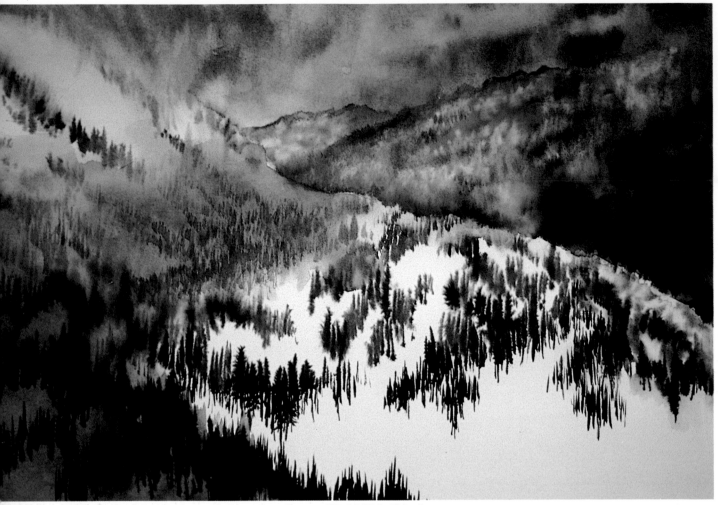

LOWERING SKY, dye color and watercolor ink on watercolor paper, 12″ × 16″ (30.4 × 40.6 cm).

An overcast sky spreads its shadowy spell across a mountain terrain, altering its color, changing its lighting, and heightening its emotional impact. With the uneven surface of a mountain's configuration, a dramatic change in the light quality produces a dramatic change in the visual and spatial information we receive. The bright light caused by an open patch in the sky is contrasted with the variety of effects caused by a foreboding firmament. After the basic composition had been established with the dye transfer method, I washed a filmy layer of color across the surface to soften the edges of the mountains and to fuse the scene into a dreamlike atmosphere. I used watercolor ink to define the pine forest. Dye colors were used to create a filmy atmosphere, while inks were used to create the more intense detailed vegetation.

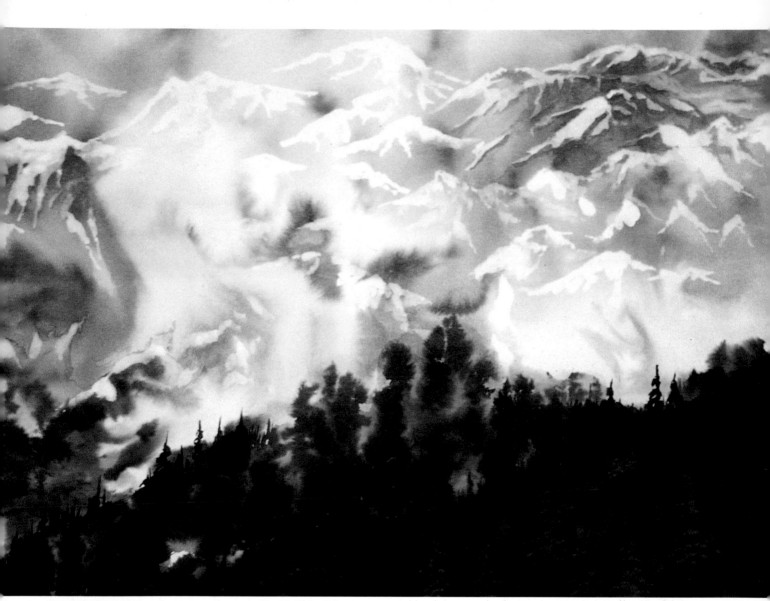

THE ENSHROUDING, dye color on watercolor paper, 20″ × 24″ (50.8 × 60.9 cm).

The intermingling of sky and land has always struck me. I have made it a constant theme in many of my paintings. The enfolding of the elements in landscapes are not only visually stimulating but philosophically and spiritually expressive. The dissolving of nature's parts into a unifying whole is a moving event emotionally. The enigmatic quality of light and shadow in The Enshrouding is exhilarating to me. The entire sky and mountain area was first transferred to watercolor paper from rice paper and allowed to dry. I formed the mountains by extracting color with a bleach solution where the snow was to appear. The frontal trees, cast in shadow, were painted with watercolor inks.

Reserving Whites for Unity and Impact

One of the major differences between water-soluble transparent dyes, inks, tube watercolors, and oil or other opaque mediums is the use of, or nonuse of, white paint in lightening a hue. A purist watercolor artist will not use opaque paint or white paint in his or her work. The white of the unpainted surface of the paper is the source of lightness or whiteness in the painting. To me, there is no virtue in using transparent paint if you mix white with the medium and make it opaque.

Because of this self-imposed limitation, a great deal of planning is necessary before beginning a painting. For the purist, painting is a problem-solving event for a number of reasons, but one of the most important is reserving the whiteness of the paper. The original whiteness of the paper can be used to add drama to a scene. I use my unpainted surface principally for snow and cloud formations. But you can use the whiteness of the paper to actually represent various images that unify the other painted areas of the picture. In some instances, it serves as a cohesive background for all the other images. Sometimes you can use its contrasting quality, as in a white snow-capped mountain placed against a dark ominous sky or a pure white snow field silhouetted against a dark grove of pines.

The white surface of the paper is of such importance it is often dominant in the painting to the point of being the subject matter. Some of my most successful paintings are those in which the white areas of the picture are equal to or cover a greater surface than the painted areas. When treated correctly, the whiteness of the paper can become an imaginary, undefined area of mystery.

The sky may not reveal its source of light, yet an area of landmass may be flooded with a radiance from an indiscernible source. The first light following a storm is often seen in the higher altitudes. In First Light, *I wanted to contrast the foreboding sky with the dazzling white of the snow-covered mountain and light meadow below. The entire surface of a small lake reflects the brilliant mountain of snow. Caution was taken to keep all color from this white area of the paper. I used three strips of dye-colored rice paper in creating this painting. I cut the sky piece from the rice paper and added several shades of blue dye color. To produce textural edges for the distant hill, I tore a thin strip of rice paper from the sheet. Black dye from a Mr. Sketch marker was placed on this narrow piece. The yellow ocher grass in the meadow was created from a third torn piece of rice paper. Once the colored shapes were in place on a piece of hot-press watercolor paper, I added moisture to each piece until the image had been transferred to the watercolor paper. After the saturated rice paper strips were lifted, I painted individual fir trees into the foreground with watercolor ink.*

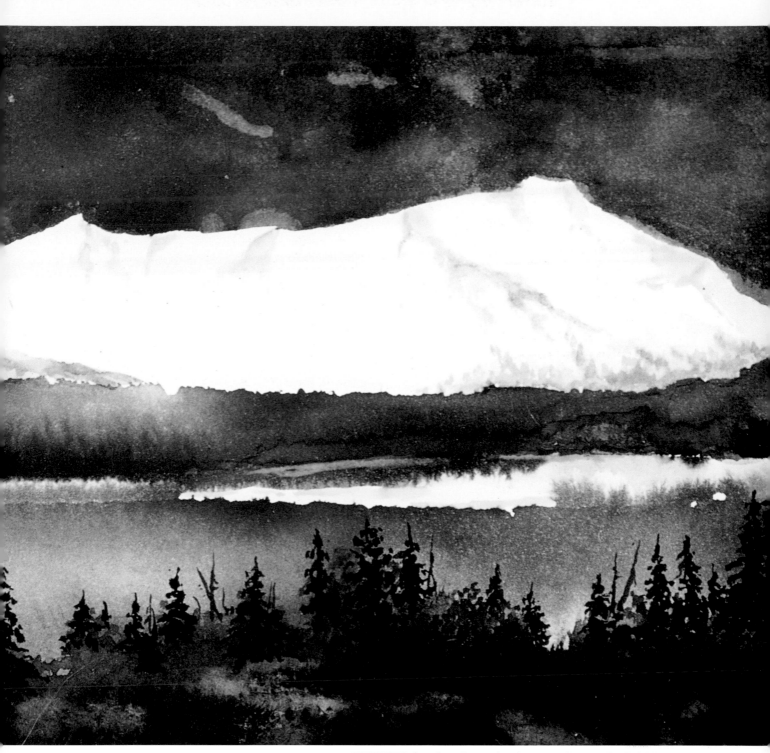

FIRST LIGHT, dye color and watercolor ink on watercolor paper, 8″ × 10″ (20.3 × 25.4 cm).

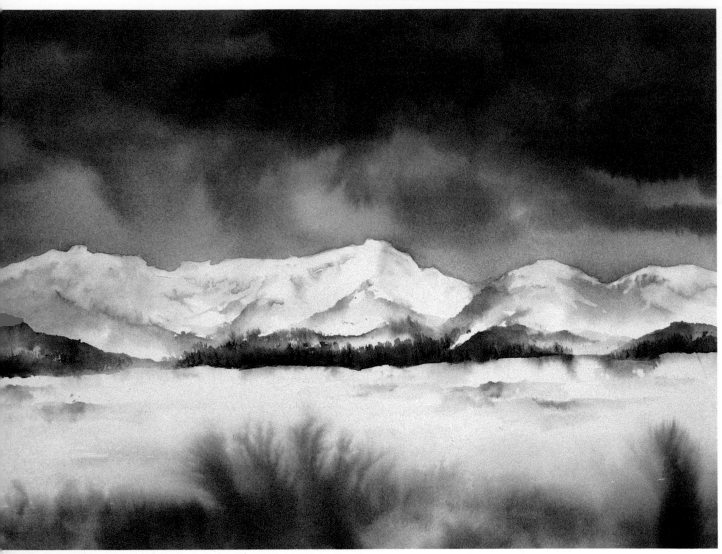

BLIZZARD SIGNS, dye color and watercolor ink on watercolor paper, 10" × 12" (25.4 × 30.4 cm).

This painting conveys the brooding quality of the mountain landscape in winter, when large expanses of pure white snow stand in marked contrast to dark, chilling skies that threaten even more snowfall.

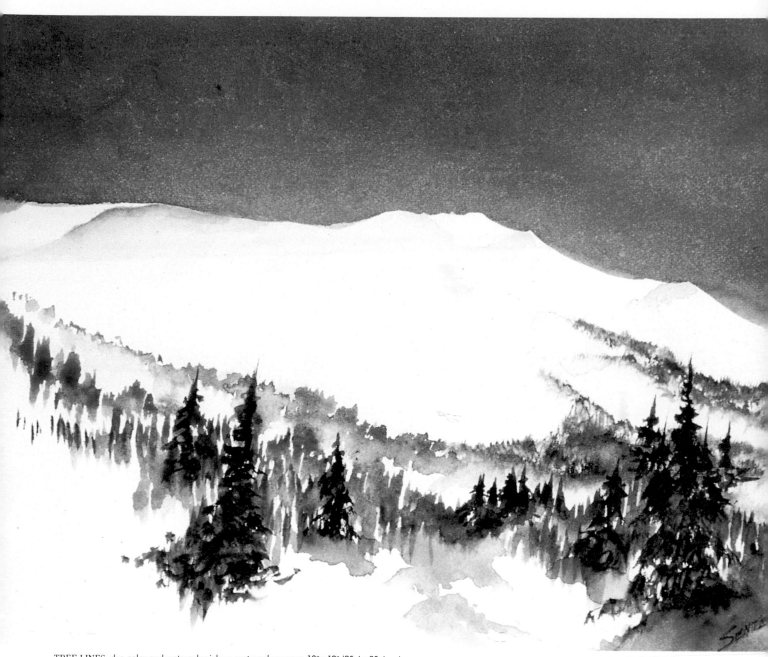

TREE LINES, dye color and watercolor ink on watercolor paper, 10″ × 12″ (25.4 × 30.4 cm).

When heavy snows invade a mountainous region, filling every crevice and leveling every crag, only the tall pines escape the canopy of white to form long lines seemingly ascending and descending upon the mountain. Tree Lines shows the negative space of the unpainted paper dominating the expression with its brightness, overall area, and contrast with a dark sky. The composition of the painting is simple, but the emotional content of the scene more than makes up for this simplicity. I used the dye transfer method for the sky. I added the trees with watercolor ink.

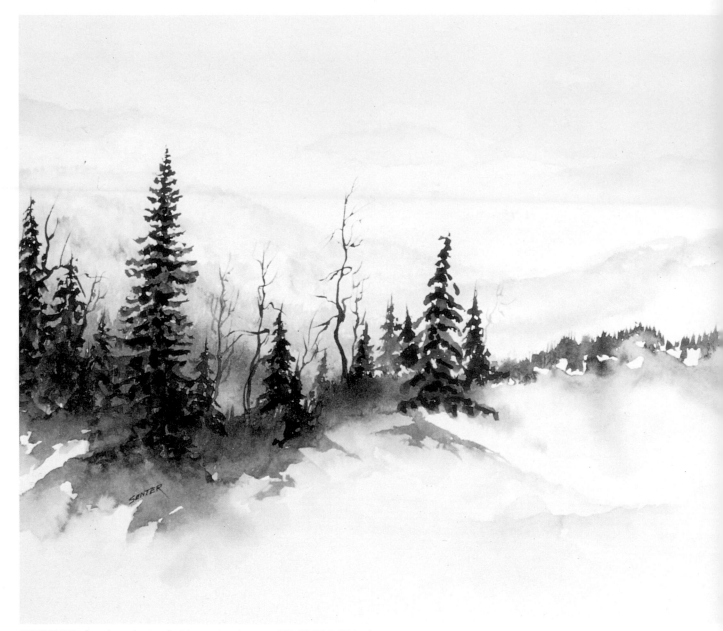

SNOW BOUND, dye color and watercolor ink on watercolor paper, 10″ × 12″ (25.4 × 30.4 cm).

The simplicity of this painting creates a quality of ambiguity, solitude, and serenity. Although two-thirds of the entire picture space is unpainted, it is not perceived as an empty void. A very light image of a distant hill provides an area of penetration for the eyes, and the shadows cast by trees give some substance to the snow-covered foreground. The large expanse of white is the subject matter of the picture; it provides an emotional impact of loneliness and isolation. I painted the vegetation with water-color ink to heighten its contrast with the stark white void of the snow field. I made the trees a solid color so they would not compete with the barren landscape.

Stark contrasts between snow drifts, evergreens, bare shrubs, and a bleak sky produce a strong, interesting composition. The shadows cast from the trees and bushes act as transitional links to the brilliant snow. I painted the sky by the rice paper transfer method, and for the ground cover I used watercolor inks. By painting the vegetation and sky very dark, I was able to make the paper appear whiter than it actually is.

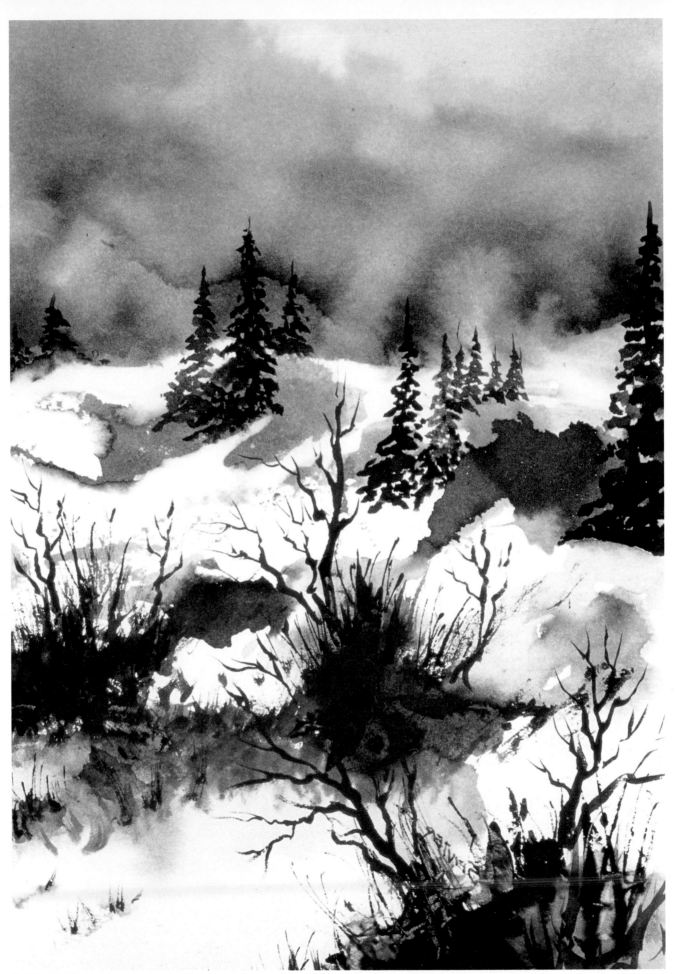

SPRING DRIFTS, dye color and watercolor inks on watercolor paper, 12″×16″ (30.4 × 40.6 cm).

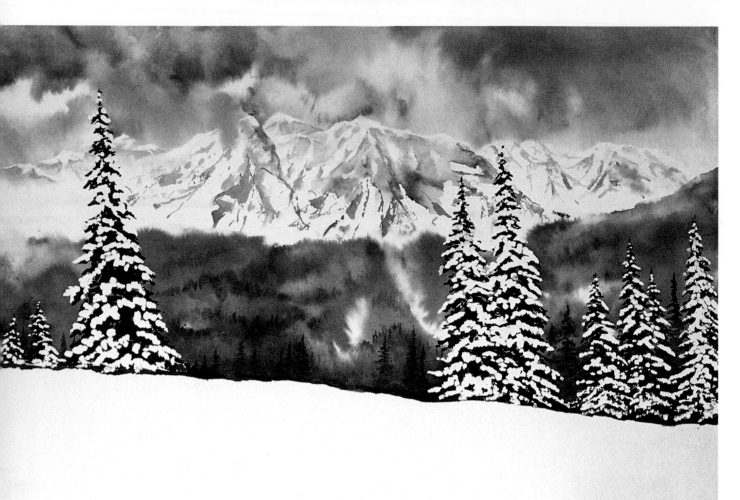

WINTER PARK, dye color and watercolor ink on watecolor paper, 12″×16″ (30.4×40.6 cm).

Snow can be deceptive spatially when there are no protrusions in it, such as rock outcroppings or vegetation. Often it has a flat look, since there is no variance of color or value, thus causing it to be deceptive spatially. In Winter Park *I established distant and middle-ground objects in positions that clearly delineate the white foreground section. The large snow-covered pines give the viewer a way to assess the actual distance from the bottom of the picture plane to the tree line. The sky, distant peaks, middle-ground hills, and evergreens are three-dimensional visually and therefore cause the flat band of snow to have some spatial dimension also. The bare paper acts as a relief from the textural aspects of the rest of the painting. I created this painting in three separate steps. First, I painted the sky and high peaks with the dye transfer method. Then I tore a jagged strip from a sheet of rice paper to form the mid-distant forest. Black and blue dyes were bled through the torn paper to the watercolor paper. I then painted the individual pine trees with watercolor ink. When the medium was dry, I extracted some color with bleach to simulate snow on the tree boughs. A sense of the quiet cold pervades the composition.*

Most mountains are complex forms, with undulations and jagged outcroppings, towering pinnacles and sinking gorges, gentle slopes and sheer rock walls. In Mountain Austerity *I wanted to express the severity of some isolated peaks. The neutrality of the white paper helps hold the variety of shapes together in a unified manner. The large open space at the lower-right-hand corner is a welcome relief that contrasts with the heavily textured mountain. Because the rock rim in the foreground is so dark in value, the snow drifts collected on it appear to be much lighter and brighter than the same white paper in the background, a good example of how surrounding information can seem to alter the whiteness of the unpainted surface. I completed the entire painting by transferring dye color onto watercolor paper from rice paper.*

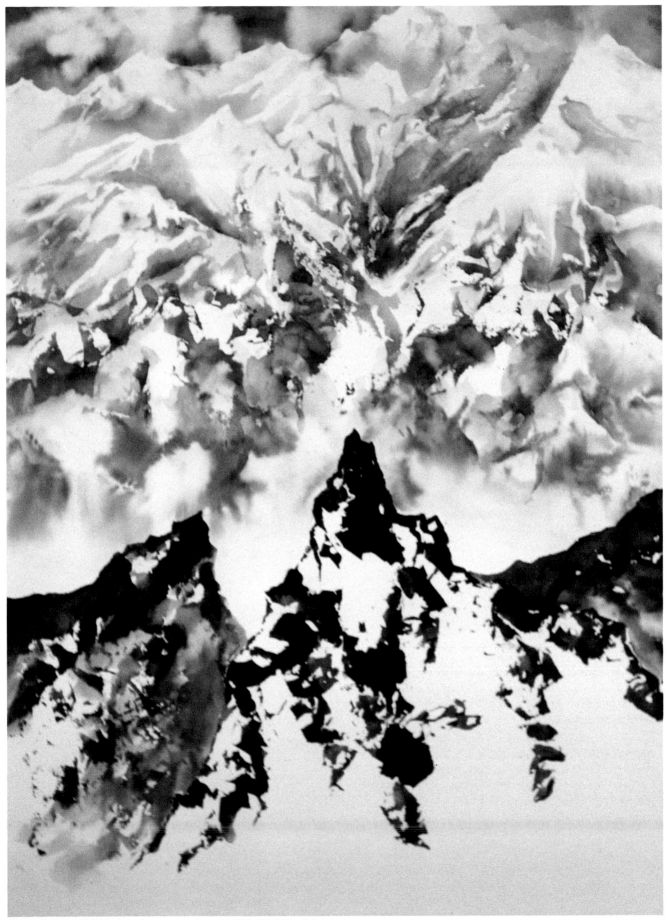

MOUNTAIN AUSTERITY, dye color on watercolor paper, 20″ × 26″ (50.8 × 66.0 cm).

Painting a Variety of Distances

When backpacking through the mountains, one soon finds oneself viewing his surroundings from a variety of vantage points. Sometimes the scenery is close at hand as when you are pushing through a thicket of shrubs or a dense growth of willows near a stream. At other times, you emerge from a dense forest and are immediately presented with a great panorama of spectacular scenery. When you stand on the rim of a deep canyon and view a tiny stream on its circuitous journey through a rocky gorge, you feel the loftiness a bird must feel at such an elevation. And when you are lying in tall meadow grass beside a rushing stream, surrounded by evergreens and quaking aspen, you feel close to nature, at one with nature.

Each visual offering is unique in its expression and produces a number of emotional experiences varying from exhilaration to quiet meditative moods. An artist will want to depict these differences. He can learn much from Japanese environmental planners, who believe the highest quality of exterior space surrounding any dwelling should consist of intimate space with perhaps a single item, such as a unique rock; a more general functional space, such as a stone pathway; aesthetically placed trees or an area of water; and a distant vista where the eye can be unrestricted in its viewing. A landscape painter is wise to incorporate some of these spatial principles into his or her work.

Forms and spaces in the mountains are very misleading at high elevations. I have learned to calculate the degree of difficulty and time needed at almost double when I am planning an assault on a distant peak or on a descent into a canyon. Things are not always as they seem visually, and great care has to be exercised to achieve the correct approach to mountain climbing lest you risk your personal safety through exhaustion. The Ascent is an attempt to show the great distances along a mountain's slopes that must be ascended before the final assault on the peaks can be made. These slopes, which are often obscured by forests or clouds, make the climb appear easier than it is. I used dye color and bleach to paint the sky and higher peaks. Distant vegetation was daubed on with colored scraps of rice paper. I painted the foreground trees with watercolor inks.

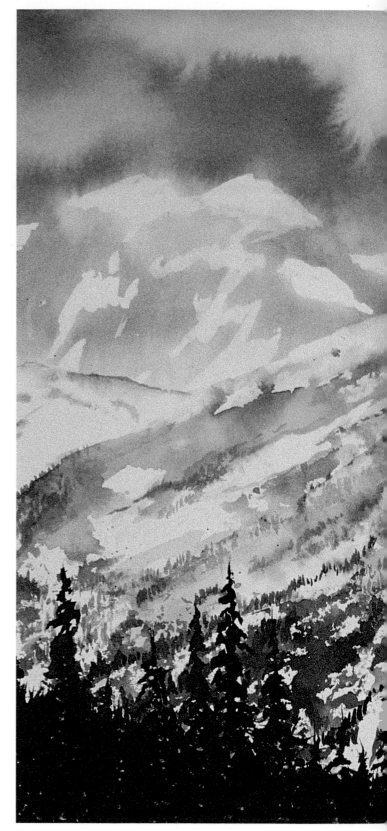

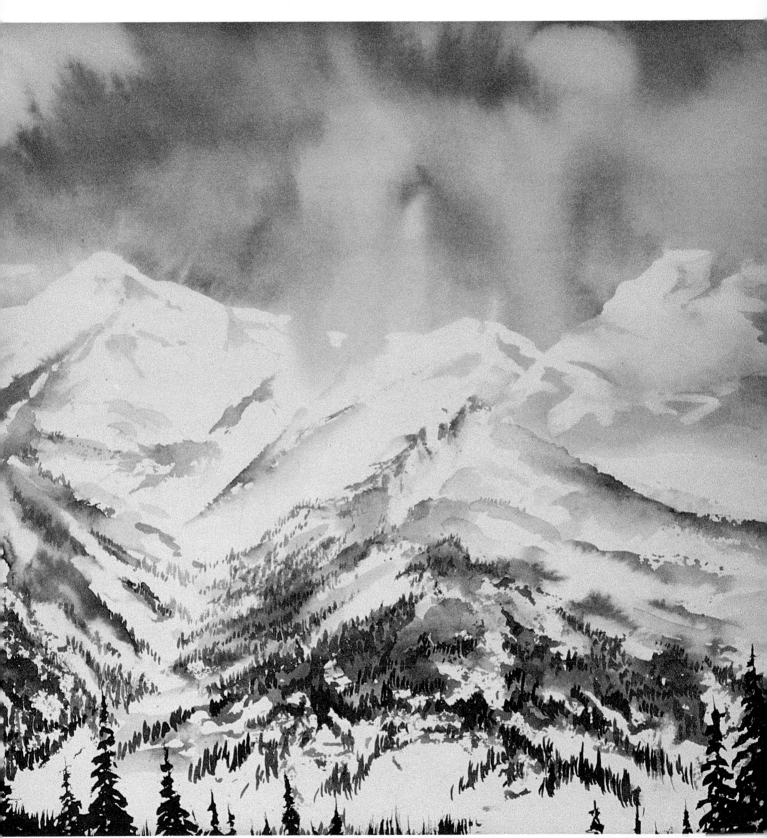

THE ASCENT, dye color and watercolor ink on watercolor paper, 14"×16" (35.5×40.6 cm).

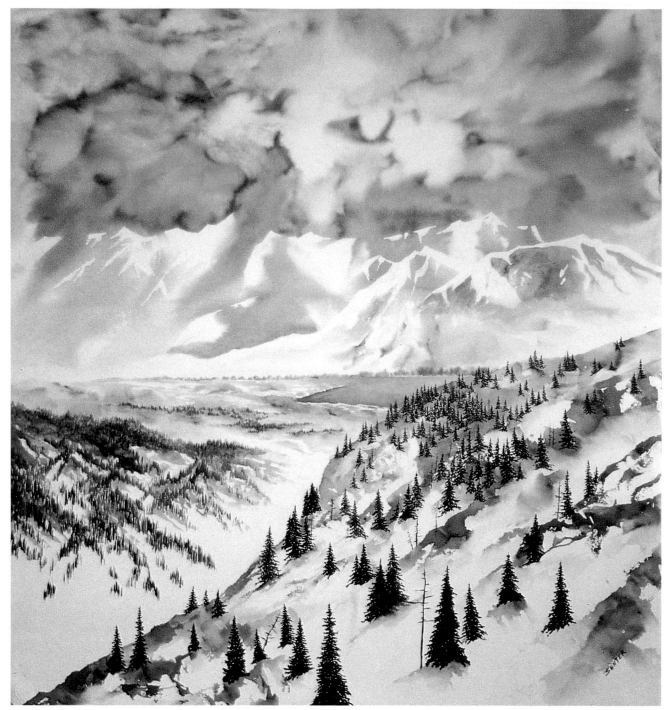

SNOW VISTA, dye color and watercolor ink on watercolor paper, 28″×30″ (71.1×76.2 cm).

Snow is a great transformer of landscapes. It fills in gaps, smooths rough edges, mutes color, and disguises spatial relationships. In Snow Vista I was interested in developing a scene in which the viewer is detached from the landscape. To do this, I placed the closest recognizable objects a great distance away. The turbulent sky reveals its ability to produce the great amounts of snow seen in both the higher altitudes and on the lowlands. Its frenzied agitation is in great contrast to the soft, serene mountain range. I planned several visual steps through this composition. The eye moves diagonally from the lower-right-hand corner, where individual pine trees can be discerned, to a more distant view, where other tree lines are suggested, to the cerulean blue lake, and finally to the mountain range. Large areas of the untouched surface of the paper are exposed, but each spatially separated area seems to exhibit its own quality of light. I painted all but the foreground trees with dye colors. A weak bleach solution was used to lighten some areas of the sky and mountains.

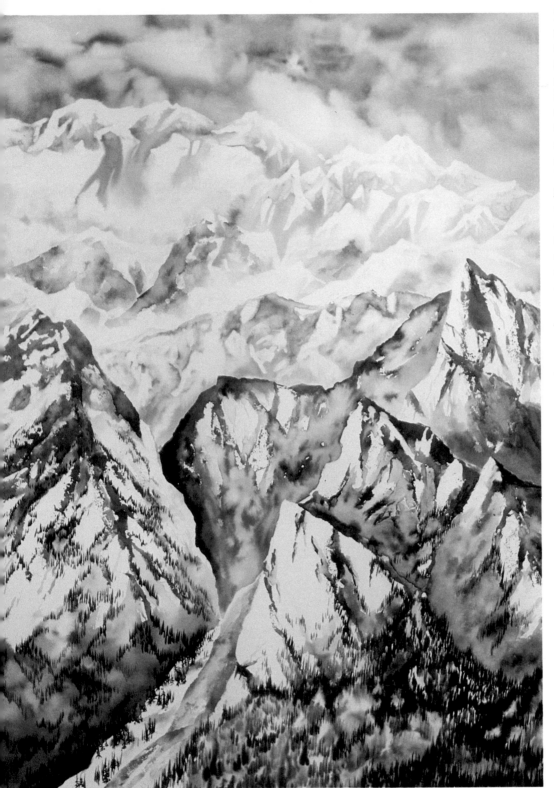

This large painting is painted vertically to emphasize the towering height of some colossal mountain summits. Their austerity and gigantic size rebuke the climber's attempt to mount them. Add to the severity of their slopes ten-foot-deep drifts of snow, and you have Unconquerable Giants. Though these monoliths are physically threatening, they exude a majestic splendor surpassing any manmade creation. The grandeur and dignity they impose on us is awesome and sublime. I accomplished the entire painting by transferring dye color from rice paper to hot-press watercolor paper. Only the trees in the foreground were painted with watercolor inks.

UNCONQUERABLE GIANTS, dye color and watercolor ink on watercolor paper, 27" × 34" (68.5 × 86.3 cm).

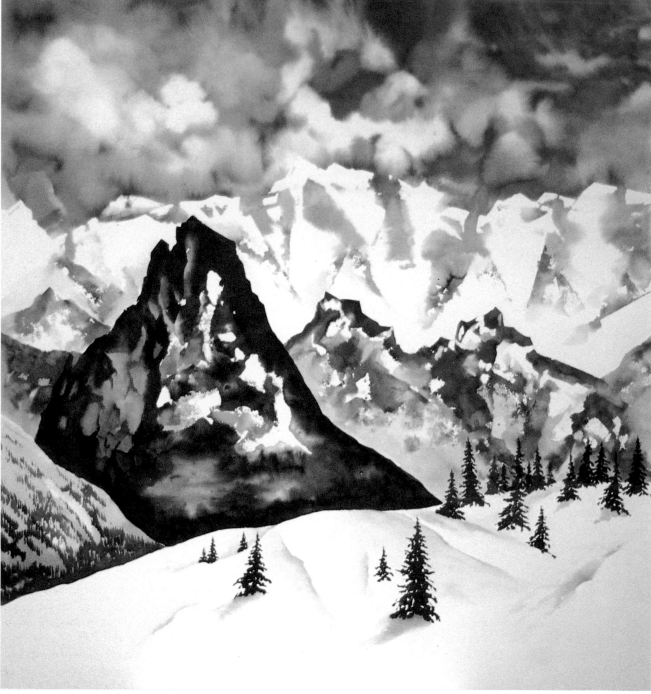

SNOW CROWN, dye color and watercolor ink on watercolor paper, 16" × 20" (40.6 × 50.8 cm).

At timberline and above, one steep crag is followed by another. Often these great monoliths will be interrupted by vast snow fields. The comparisons between the two are remarkable and overwhelming to experience. The jagged rock spires are threatening visually, while the beautiful sand-dune-like snow drifts are calming and inviting. The turbulent sky helps to heighten the tension of the rising peaks and explains the depth of the foreground snow. I formed the sky amd mountains using the dye transfer technique. I painted the individual trees with watercolor inks.

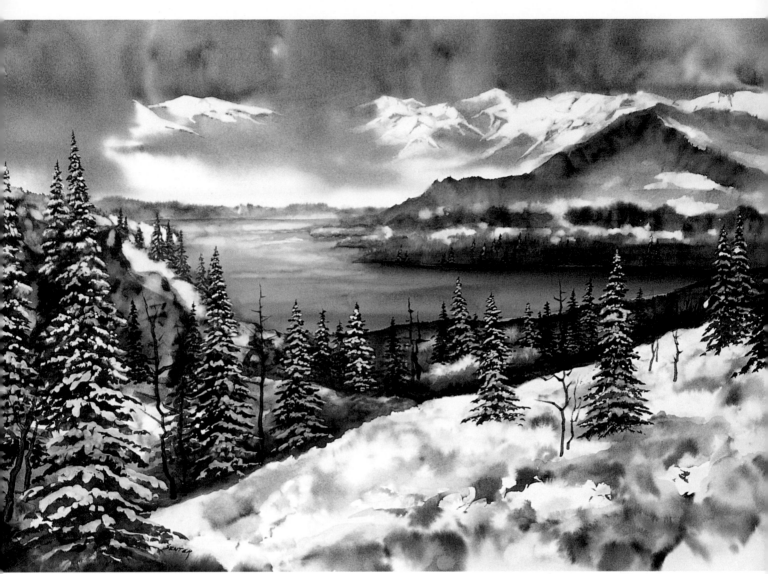

WINTER BARRICADE, dye color and watercolor ink on watercolor paper, 12″ × 16″ (30.4 × 40.6 cm).

The high ridges of the northern Rocky Mountain chain are inundated with snow six months out of the year. The lower altitudes are snowbound from three to four months in winter. The depths of the drifts prohibit the penetration of such a landscape by hikers without skis or snowshoes. The distant, rugged range is softened by the vast amount of snow deposited by low-hanging clouds, and the cold lake is surrounded by heavy stands of snow-covered pines. To create the sky in this paint- *ing, I used the dye transfer method. While the paper was still wet, I applied a weak solution of bleach and water to lighten the value of the blue and black dye colors. When the area was dry, I used a stronger solution of bleach to form the distant snow-covered peaks. I used the same technique to paint the open area of the hillside in the left part of the foreground. The darker hill in the middle distance, the lake, and the detailed pine trees were painted with watercolor inks.*

A Closer View of Nature

As inspiring and invigorating as the panorama of a breathtaking landscape may be, we still need to experience that closer view of nature, which we can touch and hear as well as see. In such places we think our deepest thoughts and dream are most personal dreams. We feel ourselves a part of nature as we are enclosed by it. This private place could be one of many found in nature, perhaps by the edge of a crystal-clear glacier lake or a small stream. It could be a spot deep in a canyon or a glade in the forest, a cave in the cliff, or a rock near a waterfall.

Places like these are the intimate environments I have frequented and experienced, personal spaces where we feel attached rather than panoramic spaces where we feel detached. Clearest in my memory are the experiences I have known there. It is to those places I find myself returning over and over again through the years. Time moves slowly when we are enveloped in a mountain environment, and personal problems seem less threatening there.

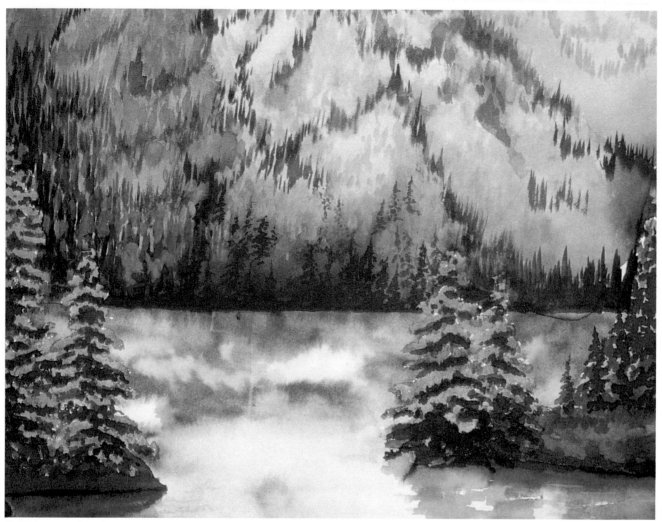

RAINBOW LAKE, dye color and watercolor paint on watercolor paper, 12″×14″ (30.4×35.5 cm).

If an interesting light is falling on a certain place, it can transform that immediate area into a segment of landscape more intriguing than the entire scene. In Rainbow Lake *I wanted to depict this phenomenon as the sun descended and the scene became a quiet dim-lit fantasy. One of the canyons formed by the side of the mountain was becoming enshrouded in darkness; the other side was receiving a soft, hazy light.*

The full light and reflected brilliance of the sky shone on the lake. I painted large pines in the foreground to establish a spatial measuring stick for the eye. A sheet of dye-colored rice paper yielded the vague colors on the mountain side. I used a Mr. Sketch marker to produce the sky by bleeding the dye through rice paper. Distant trees and foreground pines were painted with watercolor paints.

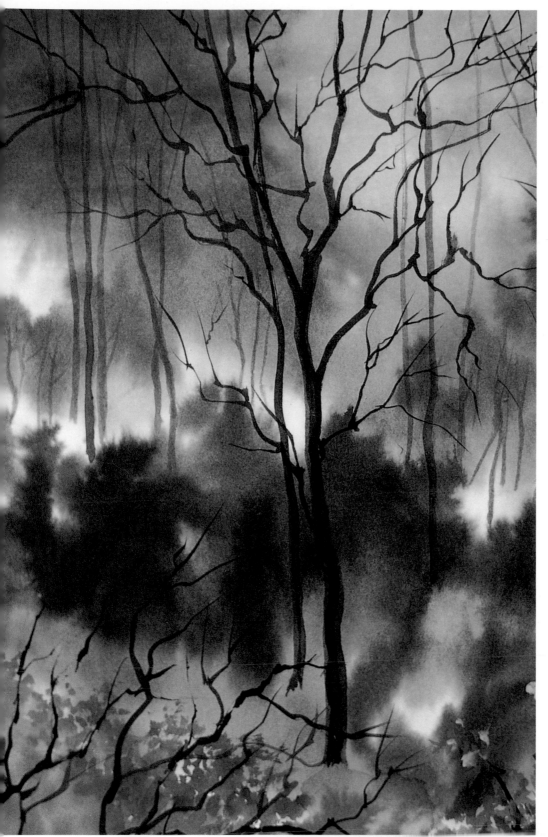

Walking through an all-encompassing environment of trees is like being in a great cathedral. The density of the leaves and branches shut out all but a few shafts of light that penetrate the forest floor. The tranquillity of the atmosphere suggests a spiritual dimension. The subdued light and height of the surrounding trees add to this sense of reality. In this painting, I transferred various shades of blue and green dye marker color to a moistened sheet of watercolor paper to present the background and middle-distant trees. I painted the foreground bushes and tall individual tree with watercolor ink.

FOREST CATHEDRAL, dye color and watercolor ink on watercolor paper, 14" × 18" (35.5 × 45.7 cm).

Expressing the Landscape's Dramatic Moods

I consider all mountainous landscapes dramatic in the sense that their structures are wondrous to behold and their complexities satisfying to contemplate. Beyond being dramatic, some landscapes have the ability to influence our emotions with their somber moods. Usually these moods are created by great contrasts in light and shadow rather than by some spectacular scene.

The poet, songwriter, and artist have always equated storms in nature with disturbances in the soul. There seems to be a direct relationship between what we see in nature and what we feel in our inmost being.

A landscape does not have to be complex to emit a strong mood. If it is explicable in expressing a truth, it will have a strong mood. The paintings in this section exhibit the paradox of darkness and light, of peacefulness and anxiety. Sometimes the sky is overcast while the earth is flooded with light. Sometimes the land is obscured while the sky is luminous. Sometimes the sky and earth are both dark and light respectively.

Such landscapes lodge themselves in my memory to be remembered and experienced over and over. Their interpretation can be profound.

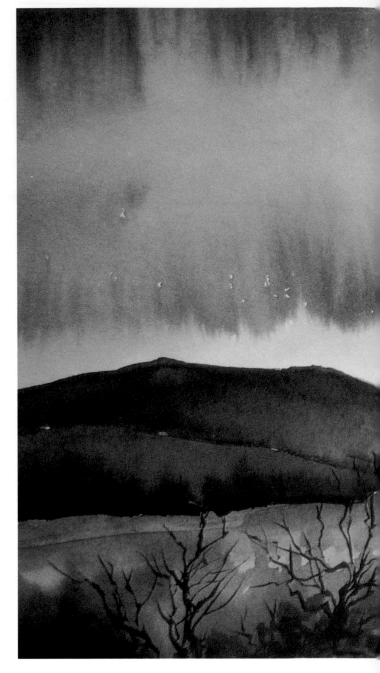

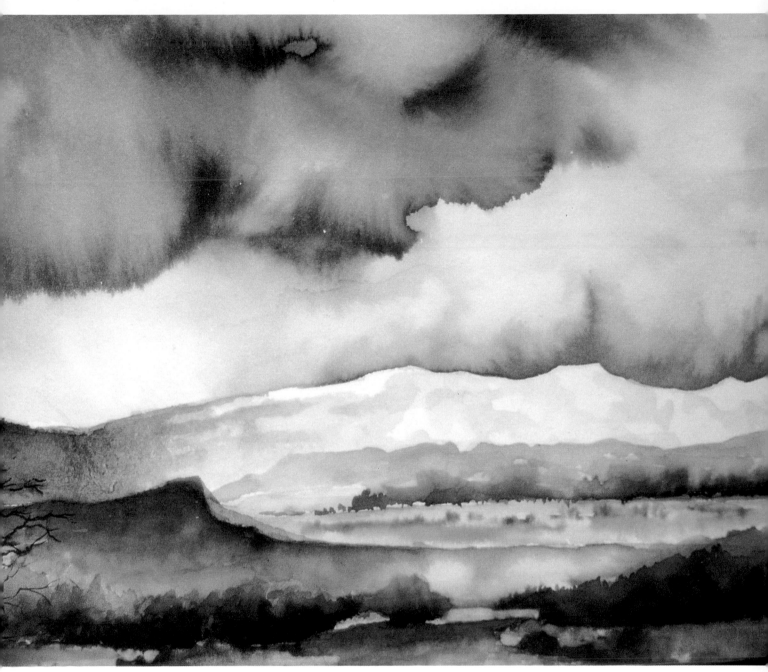

IN TRANSITION, dye color and watercolor ink on watercolor paper, 8″ × 14″ (20.3 × 35.6 cm).

This small painting is an example of how dramatically a land's mood can be altered by a rapidly changing sky. It is a scene typical of the lowlands of western Colorado and northern Wyoming. On this one ridge of hills, values vary greatly. One portion is nearly black, the other pure white. The fast-moving storm produces an eerie light and a sense of turmoil.

Since the sky dominates more than one-half of the painting's surface, it has to be painted with power. The lower portion of the landscape is tranquil compared to the agitated firmament. Using the dye transfer method, I formed the sky. The hills were shaped by eliminating the dye color with bleach. The lower third of the painting was done with watercolor ink.

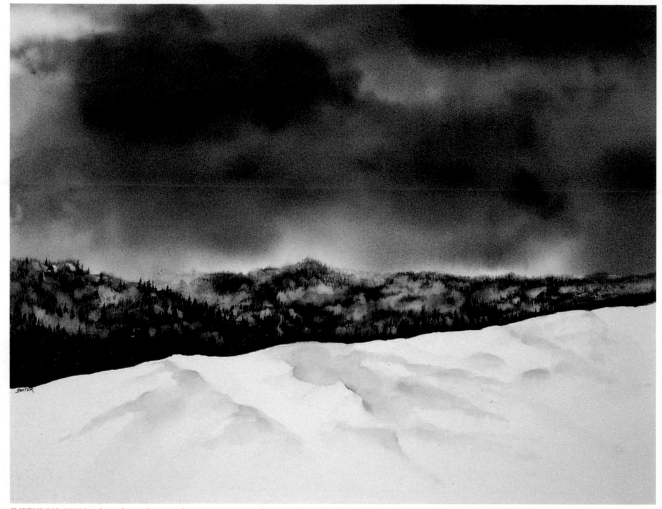

IMPENDING STORM, dye color and watercolor paint on watercolor paper, 14″ × 20″ (35.5 × 50.8 cm).

The three areas of sky, middle-distant hills, and high-foreground ridge are the actors in this somber drama. The blue-gray hill is the supporting actor for the sky and snow field. There is the feeling of immediacy in this simple composition, since the murky sky is about to engulf the last bit of light flooding the snow crest. The light seems ethereal because its source does not seem to come from the lower atmosphere. Be-sides acting as a wedge between the sky and the summit, the tree-covered hills establish spatial distances in the picture. I painted the sky with the dye transfer method. The middle-ground and foreground area were painted with watercolor paint. The subtle indentations in the snow help to visually place the viewer near the edge of a great dropoff, thus adding an emotional sensation to the painting.

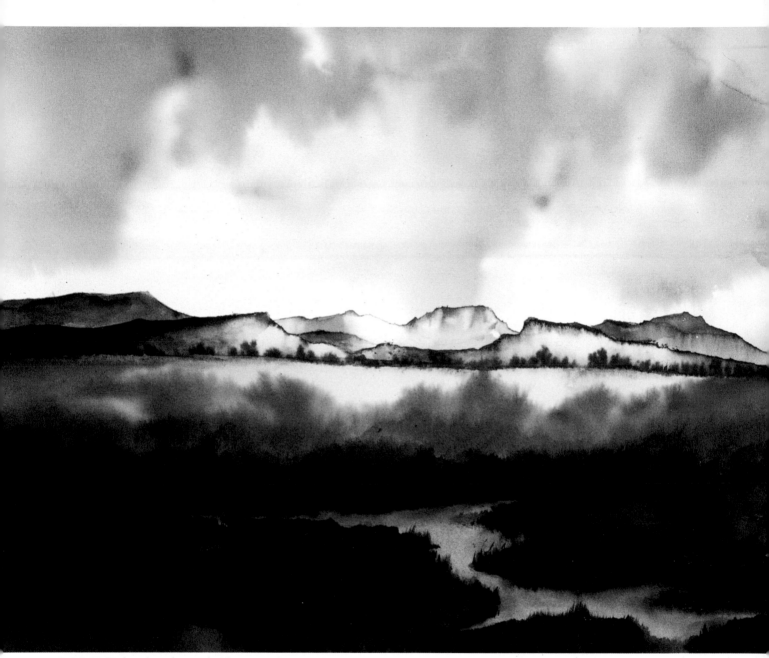

BEAVER RIDGE, dye color and watercolor ink on watercolor paper, 10" × 14" (25.4 × 35.5 cm).

In Beaver Ridge *the sky is nonthreatening, and much of the land is in shadow. The middle-distant hills are featured in this painting by spotlighting them. The distant ridges are interesting because of their lighting and their aesthetic qualities— delicate in nature and interesting in shape. The small stream in the foreground acts as a secondary point of interest, running through an obscure section of land and reflecting some of* the light in the sky. It carries the eye from the front right-hand corner into the painting. I painted the sky by washing in a very light color of dye through rice paper. For the hills and foreground I used watercolor ink. The soft, sensitive clouds are contrasted with the irregular, textural outcroppings and the jagged-edged stream. The mood here is serene rather than agitated.

This photo was taken in the first week of October near timberline on Cottonwood Pass in western Colorado. The first snow of the season was in progress, dusting the higher elevations with their first white. The dark rock ledges and the black silhouetted pines are in sharp contrast with the light sky and brilliant snow. The air is clear and the land is clean in this landscape. Because there is so little color in the scene, it relies on the changing mood for its subject matter. The shrouded mountaintops provide the picture with a sense of mystery.

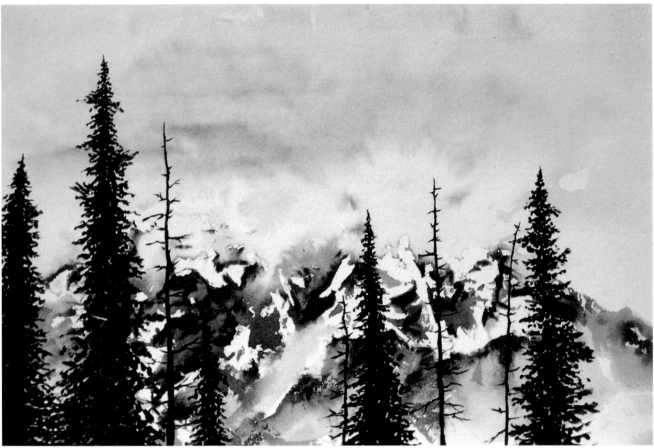

COTTONWOOD PASS, dye color on watercolor paper, 12″×15″ (30.4×38.1 cm).

I kept the color muted and emphasized value contrasts. I completed the sky area by washing a thin layer of gray dye color onto moistened watercolor paper. I formed the haze-covered mountain peaks and jagged rock walls by daubing pieces of color-soaked rice paper onto the dry surface of the watercolor paper. I drew the fir trees with a black dye marker.

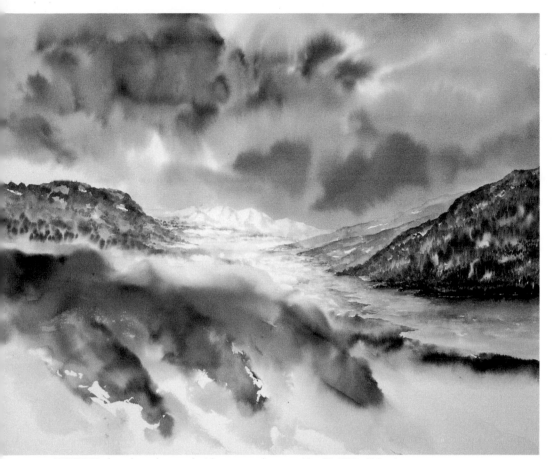

I did this painting in a monotone of grayish tans to emphasize the tumultuous nature rather than the diverse colors. An ominous sky hovers over a distant snow-covered mountain range. Small peaks create a sense of great distance. The sharper outlines of the middle-ground slopes are more pronounced than the snowy range, owing to their proximity. I kept the extreme foreground rather ambiguous and picked up the soft color of the sky. I used the dye transfer method for the sky and lower foreground. The darker hills and stream were painted with watercolor ink. When portions of the painting require soft unde-fined color fields, the water-color paper receiving the color is kept moist. When more and clearer details are to be revealed, the paper must remain dry.

SKY HAVOC, dye color and watercolor ink on watercolor paper, 14″ × 20″ (35.5 × 50.8 cm).

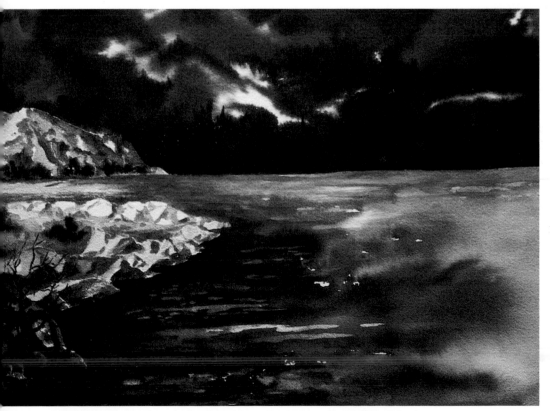

Some mountain landscapes change very little throughout the day because their light is steady. This section of Rain-bow Lake near Buena Vista, Colorado, extends into shad-owy coves, where only small portions of light periodically fall on surrounding configu-rations. The mood is peaceful in this outdoor sanctuary. A ray of light falls on a rock-strewn shoreline and bal-ances the composition visu-ally, adding a spark of interest to the dimly lit envi-ronment. The heavily forested background and lake were painted with dye markers to give an ambiguity to the scene. The rocks and shore-line were painted with water-color paint, since there needed to be a more detailed description of the foreground landscape elements possess-ing hard edges.

RAINBOW LAKE, dye color and watercolor paint on watercolor paper, 8″ × 10″ (20.3 × 25.4 cm).

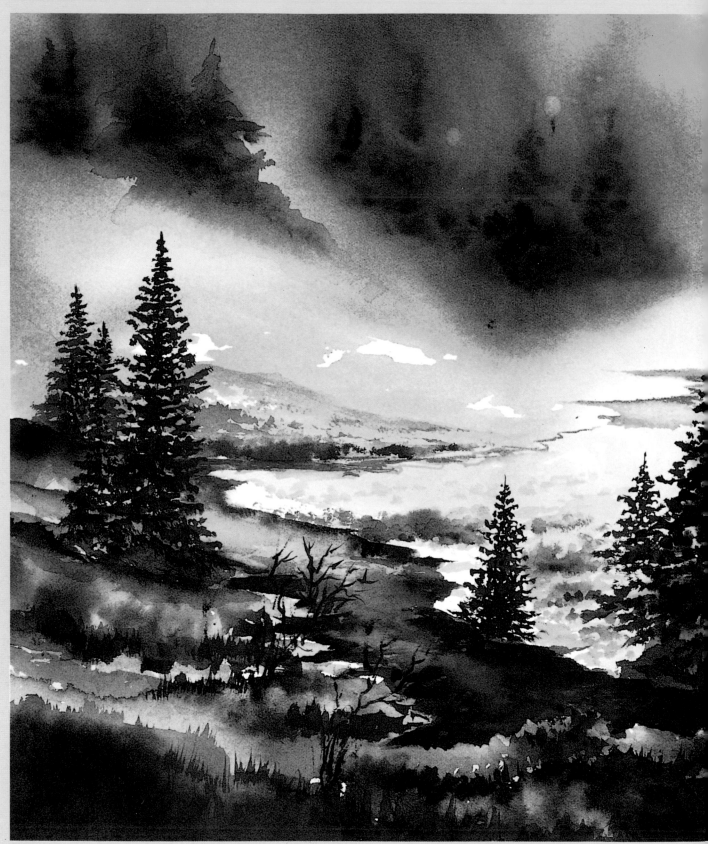

MEADOW MIST, dye color and watercolor paint on watercolor paper, 10″×12″ (25.4×30.4 cm).

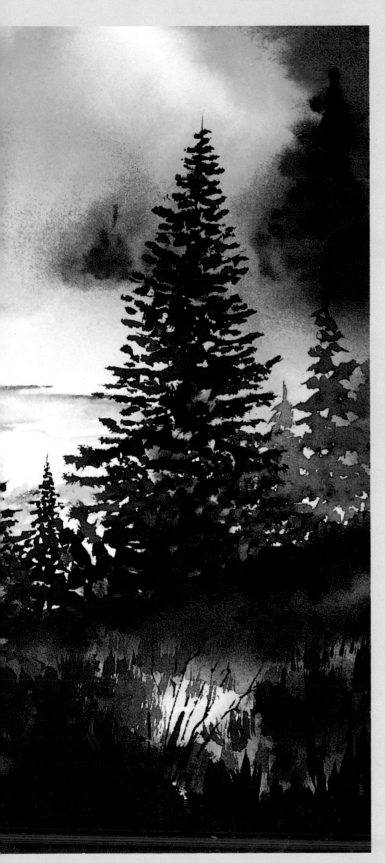

CARING FOR FINISHED WORKS

PROTECTING AND PRESENTING YOUR PAINTINGS

After successfully making a personal statement concerning a view of nature, I feel it is imperative to present my expression in the most impressive way possible. Too often, significant paintings have been demeaned by being placed into garish-looking mats and frames.

I am not concerned in this section with presenting a detailed all-inclusive chapter on the mechanics of matting and framing. I am mainly interested in commenting on the matting and framing processes unique to dye and ink preservation and presentation. Obviously, there are important aesthetic reasons for matting and framing a work of art, but in the case of such perishable media as these, protection is of equal importance.

MATTING

The reasons for providing a mat for a painting are both practical and aesthetic. The practical aspect is to separate the painted surface from the surface of the glass. Because the delicate dye colors are easily damaged and altered, they must not come into contact with any other material. The most important aesthetic reason for matting a painting is to provide a neutral area in which the painting can be viewed without the competition of surrounding sources. It isolates the picture so that the eye can fully focus and concentrate on its painted surface. Also, a proper mat will heighten the impact of the painted message and its images. In landscape paintings, the mat tends to present the subject matter as a single, limited, comprehensible segment of nature.

It is important to use only pure, acid-free rag board when matting and backing a painting. This will eliminate chances of discoloration of both the mat board and the painting. I have found that a white, 100 percent rag, double-ply, museum mat board is the best material for preserving a painting. The tape that adheres the painting to the mat board should

also be acid-free. Linen tape is the safest adhesive for this purpose.

Traditionally, many artists make the bottom margin of the mat somewhat larger than the other three sides to compensate for an assumed optical illusion. I personally do not see the need for this; the less attention paid to the mat, the better. Nor do I recommend using a double mat on a painting. This practice tends to be too decorative and focuses attention on the mat rather than the painting.

The correct width of each mat cut for each painting is an aesthetic judgment. Too small a mat will cheapen the presentation of the painting. Too large a mat will lessen the impact of the painted statement. I would rather err slightly on the side of the larger size than the smaller. Usually I place a four-inch mat around a painting when all four sides measure sixteen inches or more. Occasionally, I will enclose a small painting in a large mat, but the scene has to have a certain complexity for this.

Matting material is produced in every conceivable weight, texture, paper quality, and color. Much has been written about complementing the painting with an attractively colored mat. Some mats are so elaborate that they steal the scene. I follow a rule I never break. So that colors in the painting don't have to compete with the surroundings, I use only the whitest and highest-quality mat board available and frames of a neutral color.

To protect the delicate dyes and inks, I always use a heavier mat board than is normally needed in separating them from the surface of the glass. Some of the dye colors are so subtle and low in value that they have to be seen against a purity of whiteness for best advantage. To retain the original quality of each color, the mat has to be a quality white. As for texture on mats, I feel it draws attention to its surface and away from the painting. I cut and bevel all of my own mats using a Dexter mat cutter.

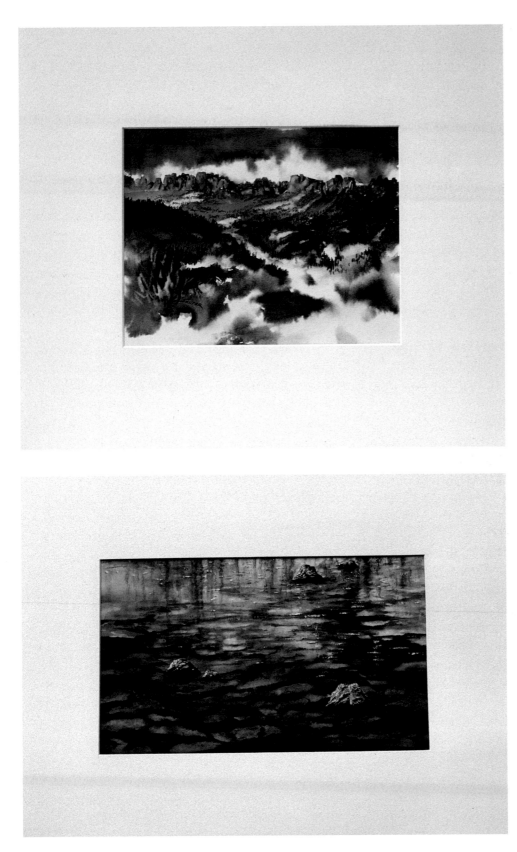

In some instances, the isolation of a small painting by the use of a wide mat adds a sense of dignity and richness to the work. There is a gem-like quality to its appearance.

The correct width of a mat on any painting is an aesthetic decision that has to do with a perceived balance of neutral area to painted surface.

FRAMING

I purchase my frames ready-made. One has to be careful in choosing a frame because its appearance and strength can be deceptive. After some investigation, I found frames of high quality that were carefully built and beautifully finished. Quality frames can be costly, but any amount spent in displaying an important painting is well worth the price.

A frame's reason for being is much the same as that of a mat. It physically holds the painting, mat, and glass together and provides a way to hang the painting. Like the mat, the frame has to be considered aesthetically also. A frame should not overpower a painting. A too-decorative surface with colors that distract the eye is not a good choice.

For paintings from eight to twenty-four inches, I use silver or matte gray metal frames, which are easy to assemble and which show the painting at its best. For pictures over 24 inches, I use wooden frames, since the glass for this size painting needs the support of a larger, stronger frame. Visually, a larger wooden frame looks better on a larger painting.

The type of glass selected for the frame is of utmost importance. Nonglare glass is popular with some people, but I find that it distorts both the colors and the images, and so I don't use it. If the viewer is not standing in just the right place, nonglare glass will not allow the painting to be seen at all.

Plexiglas is often used in framing because of its lighter weight and strength against breakage. But it has disadvantages as well. It is not as clear as single-strength glass, its surface is easily scratched, and it readily attracts dust particles. Also, it is more expensive than glass. Unless the size of my painting warrants the use of Plexiglas, I will not use it.

Regular single-strength glass presents the painting in the best manner. If one wishes to guard the dye and ink colors from ultraviolet light, a plastic laminate called Print Guard can be adhered to the glass surface by a pressure-sensitive machine found in most photography laboratories. (See section on Lightfastness.)

After the painting, mat, glass, and backing have been attached to the frame, the back of the frame should be sealed to protect the mat and painting from moisture, dust, and insects. A heavy paper and masking tape work best for this seal.

HANGING LOCATIONS

Dye, ink, and watercolor paintings should not be hung in direct sunlight, since ultraviolet rays will alter sensitive colors. The rate of fading is slowed by placing paintings in indirect light. Fluorescent lights will also accelerate the fading process. You can purchase ultraviolet filters for fluorescent lights.

Because dyes and watercolor inks are so delicate and sensitive to moisture, it is imperative that they be protected from any kind of humidity. A humid environment will affect not only the colors of the painting but the color of the mat as well.

When the degree of humidity in the interior atmosphere of the painting differs from the outside, moisture will condense on the inside surface of the glass and eventually destroy the painting. If this occurs, the frame must be disassembled and the moisture removed. In view of this, don't hang paintings in bathrooms or kitchens or against brick or stone walls, where moisture is apt to seep through.

Ventilation is important to a painting, so there should be air circulation around the picture to prevent moisture from building up and penetrating the frame and glass. Remember that high heat accelerates deterioration of artwork. Don't hang pictures over air vents, heat registers, or near fireplaces.

STORING FINISHED PAINTINGS

The best place to store finished watercolor paintings is in a room with a temperature between 60 and 75 degrees. Place them in racks several inches above the floor to protect them from possible water damage. Place them vertically with room between to allow for the circulation of air. I use plywood panels four feet tall, four feet long, eighteen inches wide, with an open top, to store matted and unmatted paintings. Don't store paintings in damp places or extremely dry, hot places.

Finished works should not lean against one another, since color can be transferred from one painting to another if there is the slightest amount of moisture or if any pressure is applied. The storage area should be dust-free and void of excessive light. Paintings should be easily accessible so they can be moved without damage from their storage place. If possible, store works in several size categories so that smaller paintings will not become wedged between larger ones. Make slides of every successful painting as a record, in case of sale.

Silver or pewter metal frames present pictures well. The size and color of these framing materials are subservient to the painting.

INDEX